IMAGES
of America

# TALL SHIPS ON
# PUGET SOUND

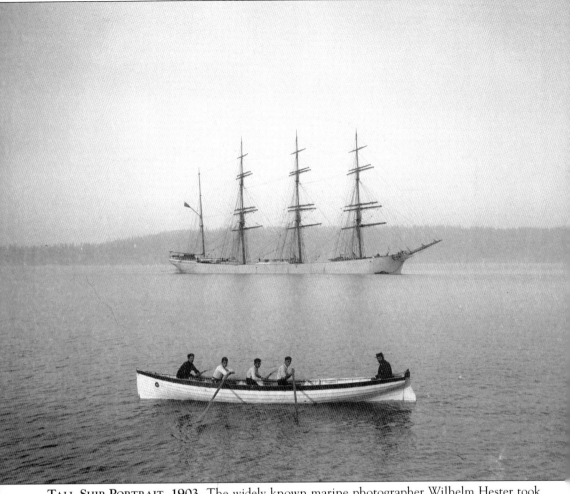

**TALL SHIP PORTRAIT, 1903.** The widely known marine photographer Wilhelm Hester took this classic photograph of the four-mast, 317-foot-long bark *Fortevoit*, shown in 1903 anchored in Tacoma's Commencement Bay with its ship's boat and crew in the foreground. This was a common scene during the late 1800s and early 1900s as hundreds of tall sailing ships took on cargos of grain, lumber, coal, and similar products at Puget Sound ports for shipment to cities on the Pacific Rim, Europe, and the rest of the world. The majestic *Fortevoit* was built in 1891 by W. H. Potter and Sons in Liverpool, England, and sailed the world for more than 30 years before being scrapped in 1926. It had a cargo-carrying capacity of 3,145 gross registered tons, among the largest of the major sailing ships of its era. (Courtesy University of Washington Libraries, Special Collections, Hester 10403.)

**ON THE COVER:** Massed tall sailing ships are shown berthed side-by-side in 1888 while loading lumber at the Tacoma Mill Company in Old Town. Originally known as the Hanson, Ackerson, and Company Mill, Tacoma's first lumber mill operated from 1869 to the early 1920s when it closed. The waterfront mill site typified many other such complexes around Puget Sound in the late 1800s and early part of the 1900s. The tall timber products of these mills attracted a wide variety of square-rigged and other sailing ships from the Pacific coast and elsewhere around the world. The site is now Jack Hyde Park, named for a former mayor of Tacoma who championed the mixed-use redevelopment of the Old Town and Ruston Way waterfront. (Courtesy Tacoma Public Library, No. TDS-010.)

IMAGES
*of America*

# TALL SHIPS ON
# PUGET SOUND

Chuck Fowler and the
Puget Sound Maritime Historical Society

ARCADIA
PUBLISHING

Published by Arcadia Publishing
Charleston SC, Chicago IL, Portsmouth NH, San Francisco CA

Printed in the United States of America

Library of Congress Catalog Card Number: 2007930682

For all general information contact Arcadia Publishing at:
Telephone 843-853-2070
Fax 843-853-0044
E-mail sales@arcadiapublishing.com
For customer service and orders:
Toll-Free 1-888-313-2665

Visit us on the Internet at www.arcadiapublishing.com

*To two wonderful women in my life, my late mother, Florence Fowler
Burrows, and my wife, Karla Fingerson Fowler.*

Puget Sound Maritime Historical Society

The purpose of the Puget Sound Maritime Historical Society is to provide educational opportunities and experiences for those interested in the maritime history of Puget Sound and the Pacific Northwest through the collection, preservation, exhibition of artifacts, and presentation and publication of research and general information.

For more information about the society, including membership, see the Web site at www.pugetmaritime.org or write P.O. Box 9731, Seattle, Washington, 98109-3028.

Notice of Trademark Rights

The American Sail Training Association (ASTA) is a nonprofit organization focused on youth education, leadership development, and the preservation of the maritime heritage of North America. Its membership includes hundreds of square-riggers, schooners, and many other traditionally rigged sailing vessels conducting character-building programs. ASTA actively promotes and conducts races and rallies among such vessels, as well as port events and other types of competitive and collaborative events, and is proud of its long-standing connection with Puget Sound. Tall Ships®, Tall Ships Are Coming!®, TALL SHIPS CHALLENGE®, and the sailing ship logo—among others—are federally registered trademarks/service marks owned by ASTA. Usage of any of the same within this book is with the express permission of ASTA. ASTA reserves all other rights.

# CONTENTS

# ACKNOWLEDGMENTS

The writing and editing of a book is an overwhelming task, even for those whose passion as well as education and experience have prepared them for the challenge. Images of America: *Tall Ships on Puget Sound* would not have become a reality without my own group of supportive colleagues, friends, and relatives, all of who have my deepest appreciation.

My special thanks goes to the Board of Governors of the Puget Sound Maritime Historical Society (PSMHS). The board, led by Pres. George Osborn, provided a generous grant that helped fund this book. A thank you also to the dedicated PSMHS volunteers and others who helped me find photographs, other images, and vital information in the society's collections housed at the Museum of History and Industry (MOHAI) in Seattle. I am indebted particularly to volunteers Jack Carver, Eric Lindgren, Ron Chaput, Pat Hartle, Karl House, and librarian Carole Marnet. Special thanks also to several members of the editorial board of the *Sea Chest*, the highly regarded PSMHS quarterly journal, editor Ron Burke, Michael Mjelde, Gary White, and, for his knowledge and wise counsel, the late Capt. Harold Huycke. Thanks also to MOHAI librarian Carolyn Marr and her colleagues, who work closely with the society library and curatorial volunteers, for providing outstanding research service.

Other library and archive professionals who also provided genuinely valued assistance were Bill Kooiman, J. Porter Shaw Library, San Francisco Maritime National Historical Park; Elaine Miller, Washington State Historical Society Research Center; Carla Rickerson, Nicolette Bromberg, and staff, University of Washington Libraries, Special Collections Division; Jeff Jewell, Whatcom Museum of History and Art; Marge Savage, Jefferson County Historical Society Research Center; Brian Kamens and Robert Schuler, Tacoma Public Library Northwest Room; Capt. Gene Davis, Coast Guard Museum Northwest; and Angelo Comino, State Library of Queensland, Australia.

Several relatives provided essential images and information that helped bring this book to life. My special thanks to Bill Kunigk and his wife, Peggy, and also to Roger and Carolyn Erickson. Bill's father, W. A. Kunigk, is the subject of chapter four, "A Square-Rigger Sailor's Story." Without this personal, inspirational tale and the accompanying images, this book would have been much less dramatic and relevant. Also the incredible photographs taken in 1905 onboard the square-rigger *Queen Margaret* by Fred Taylor and graciously provided to me by his grandson, Tad Lhamon, allow all of us to visually experience these adventurous days of sail.

Through the years I have been involved in several other nonprofit maritime heritage organizations, among them the Pacific Northwest Maritime Heritage Council, American Sail Training Association, Youth Adventure Inc., South Sound Maritime Heritage Association, Commencement Bay Maritime Association, and Combatant Craft of America. I value greatly the wonderful, supportive friends I have made through these organizations.

Finally, I extend my appreciation to the professionals at Arcadia Publishing, including my editor Julie Albright; Christine Talbot, publishing manager west; Devon Weston; and other staff members for their ongoing assistance throughout this book project.

# INTRODUCTION

The well-known saying about history repeating itself applies particularly well to tall sailing ships. Once thought to be virtually extinct with the advent of steam and later diesel-powered motor vessels, the majestic square-rigged and other tall ships of the past have made a dramatic comeback in recent decades. This is true especially within the United States in the Pacific Northwest and on Puget Sound in Washington State.

Both historic and modern tall ships today participate in education and training programs, offshore races, and dockside festivals. Visits of magnificent tall ship fleets to port cities in Europe, America, and elsewhere in the world have become significant public events during the past three decades.

The major tall ships gatherings that helped celebrate the nation's bicentennial in New York Harbor in 1976 and again in 1986 to mark the centennial of the Statue of Liberty drew millions of spectators and are etched in our collective memories. More recently, the successful American Sail Training Association–sponsored Tall Ships Challenge series of 2002 and 2005 attracted hundreds of thousands of people to Puget Sound host port cities and others along the Pacific coast. And continuing tall sailing ship events are scheduled during 2008 and beyond.

The relatively recent tall ships events recall the maritime eras of a century and more ago. These were times when hundreds of hardworking, traditional-design sailing ships and their crews were carrying cargo and passengers to and from bustling ports worldwide while plying the busy waters of Puget Sound, the Strait of Juan de Fuca, the Gulf of Georgia, and the coast of Washington.

In the mid-1700s, these wind-powered ships with their soaring masts and billowing sails brought the first of many explorers, settlers, entrepreneurs, fortune seekers, and others to the Puget Sound area and elsewhere in the region. When the first Spanish, French, British, Russian, and American explorers arrived in their tall ships, they were greeted by the original Salish peoples in their large, carved cedar canoes. Although not widely known, anthropologist Leslie Lincoln says in her book *Coast Salish Canoes* that, in addition to paddles, canoe crews used sails made of woven reed, bark mat, and lashed, thin cedar boards as they journeyed along the coast and throughout the sound.

The eras immediately following first contact between the indigenous Salish residents and the early European American explorers and later settlers were difficult and sometimes disastrous. However, during subsequent decades and in spite of many injustices, new relationships have been formed and accommodations made between the native and newcomer groups. During ceremonies and educational events since the Washington State Centennial commemoration of 1989, tall sailing ships and Native American canoes and their respective crew members have become increasingly important cross-cultural connectors.

Without the cargo-carrying tall ships and their hardworking crews, the Puget Sound region's sustained growth during the past two centuries would never have been achieved. However, while the society, economy, and technology have changed dramatically, the tall sailing ships—in new roles—have survived. They are now important elements of national and civic pride, cross-cultural relationships, and seagoing education, as well as powerful reminders of the maritime past.

The following pages detail more than two centuries' worth of tall ships' history as an important factor in the development of today's robust Puget Sound region. From the sailing canoes of the area's aboriginal residents, through the ships of the early explorers and growth and decline of the great age of commercial sail, to the rebirth of traditional sailing vessels as floating classrooms, this Pacific Northwest–focused story is chronicled through dramatic, many never-before-seen historical and more recent images.

Chapter one highlights the first use of wind power and sail in the region, which was by the aboriginal Salish residents. Subsequently, Spanish, French, British, Russian, and American explorers and entrepreneur sailors arrived on the northwest coast in their late-18th-century square-rigged ships and oar and sail-powered longboats.

The Puget Sound aspect of what maritime historians call America's major sailing ship era is chronicled in chapter two. This period typified the region during the late 19th century as westward expansion brought burgeoning new settlement and growth—and tall ships, their passengers, and cargo—to the U.S. Southwest and later the Pacific Northwest.

Chapter three describes how the great age of sail began to decline beginning in the late 19th and early decades of the 20th centuries, as it did elsewhere in the United States and the world. This period was marked by a transition that ended with ship lay up and storage, demolition, and a few attempts to save the tall ship shadows of the past. Wartime and a few other times of economic upturn saw some sailing ships return to sea, but most continued toward their final fate. Some of the once majestic but now old, rotting, and rusting ships were laid-up and anchored together in Seattle's Lake Union and elsewhere in the sound. Others were stripped; their once soaring masts sized down or cut off and used as barges for fish processing, lumber transport, oil and other product storage, and similar purposes.

Early in this period, however, sailing and steam ships were each carrying about half of the world's shipping cargo. With the opening of the Panama Canal in 1914, a sailing voyage around Cape Horn in South America or the Cape of Good Hope in Africa was still a challenging adventure. Chapter four chronicles the at-sea life of a young German deepwater sailor who, in 1901, sailed from Puget Sound around Cape Horn in South America and on to Europe. From 1898 to 1905, Willibald Alphons Kunigk sailed the deepwater oceans, including two around-the-world voyages, aboard nine different sailing ships under three separate flags—German, British, and American. In 1901, he signed aboard the 275-foot-long, four-mast British bark *Queen Margaret* in Tacoma and ended his voyage five months later in Antwerp, Belgium. Kunigk later returned to Puget Sound and Tacoma to settle, become a U.S. citizen, marry, pursue a successful career as a civil engineer, raise a family, and make the growing city his lifelong home.

The quiet conclusion of sailing ships as once essential elements of the Puget Sound economy is presented in chapter five. The final voyages of the cod-fishing schooners from the sound to Alaska and return took place in 1950. Subsequent years saw the ongoing loss but also preservation of a few of the old sailing ships in Puget Sound. Seemingly out of the fires and ashes of the burned ships of the previous decades, slowly there was a Phoenix-like rebirth of sailing ships.

Quietly and creatively, the glorious days of sail history returned in the early 1950s and expanded greatly beginning in the mid-1970s as both restored and re-created vessels appeared, exciting new historical and educational roles. Chapter six tells how a small group of enthusiasts, including nonprofit youth organization leaders, sailors, shipwrights, sailboat brokers and owners, educators, and others, came together informally to restore and resurrect both the boats and also the region's sailing history.

This book has been created through extensive historical research, review of countless illustrations, photographs and related materials, and interviews with many of those who have helped make this fascinating history. Learn about the fascinating ebb and flow of this colorful maritime story through its narrative and images. And see how in Puget Sound, the rest of the United States, and the world, tall ships' history has indeed repeated itself.

# One

# THE BEGINNINGS
## SAILS ON THE SOUND

Although some Pacific Northwest history books begin with what is referred to as "First Contact," the native Salish peoples had lived in the region for thousands of years before the first European and American explorers arrived. The native residents had developed their own highly organized social, cultural, political, and economic ways of life. Aspects of this initial interchange between the native peoples and the early explorers and traders were positive, but others were difficult and sometimes disastrous.

The nation-based political expansion and economic competition of the early Europeans and Americans brought significant change to the region. Maritime economic historian James Hitchman noted that, in the 18th century, "several European states used their scientific and philosophical ideas of the Enlightenment to expand their imperial pretensions." He continued, "As the Spaniards settled California with missions, the Russians found a fur trade in Alaska, the British Northwest Company probed westward while countrymen charted the Pacific rim, and Yankee traders began to call up and down the Coast." These exploratory initiatives "combined to connect the Pacific Coast with the rest of the world," Hitchman noted.

This combination of motivated military leaders and energetic trader entrepreneurs arrived in the area first by sea on sailing ships. They were followed by other mariners and overland explorers and settlers who came by foot, canoes, horses, and wagons. These hearty individuals, and those that followed them, turned the Puget Sound area's newfound natural resources into rapidly growing maritime and other commercial enterprises that fueled the area's expansion.

Today the important contributions of tall sailing ships and crews, as well as those of the native Salish peoples and their canoe culture, and the development of the region are being rediscovered, honored, and recognized. This significant legacy is being passed along to future generations so they may continue to help make and write their own colorful maritime history.

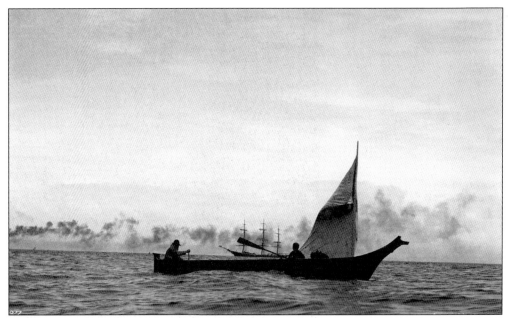

**SALISH CANOE AND TALL SHIP, 1900.** A Salish-design Makah canoe with a sail is shown as it passes before a square-rigged ship being towed toward the prevailing offshore winds in the Pacific Ocean. Before the arrival of the first European and American explorers on the northwest coast, Salish people outfitted their canoes with woven reed and other types of sails, later converting to canvas sails received in trade. (Courtesy Museum of History and Industry, Seattle, Wilse No. 88.33.25.)

**TWIN-MAST CANOE.** A Salish family used a sprit-rig, sail-equipped canoe during a journey to the Port Townsend area during the late 1800s to early 1900s. As anthropologist Leslie Lincoln has written, in addition to human paddle-power, "If conditions were right, [Salish men and women] were happy to move with the force of an accommodating wind." (Courtesy MOHAI, McCurdy No. 1955.970.470.)

10

**EARLY BRITISH EXPLORER.**
Sent by the king of England to
explore the northwest coast in
the late 18th century, British
Navy Capt. George Vancouver
led the first European
expedition to the region. He
named the body of water today
known as Puget Sound for his
second-in-command, Lt. Peter
Puget. (Courtesy Washington
State Historical Society,
Tacoma, No. 1943.42.51390.)

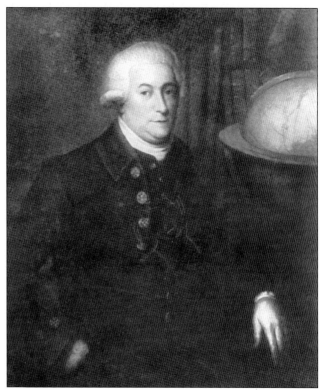

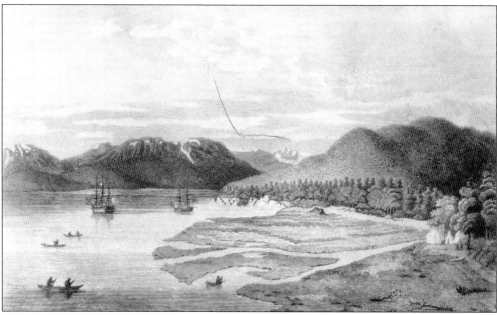

**EXPEDITION COMMAND SHIPS.** Vancouver's two ships, the HMS *Discovery* and HMS *Chatham*,
along with Salish canoes, are shown in a Puget Sound estuary landscape illustration from the
journals of Vancouver's expedition. These ships served as the command posts for the expedition,
while their oar and sail-powered longboats and crews explored the shallower, out-of-the-way waters
of the sound. (Courtesy WSHS, No. 1943.42.62735.)

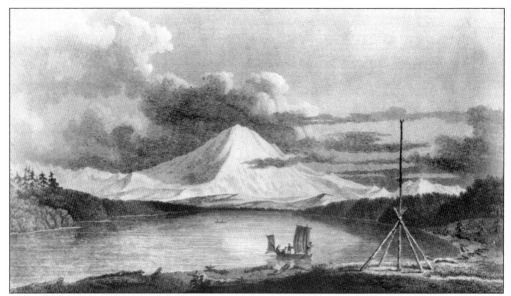

**LONGBOAT AND MOUNT RAINIER.** With Mount Rainier in the background, an expedition ship's boat with yard-rigged square sails is shown in another illustration from Vancouver's journals. Vancouver named the mountain for Rear Adm. Peter Rainier, a British naval hero and friend. (Courtesy WSHS, No. 1943.42.62731.)

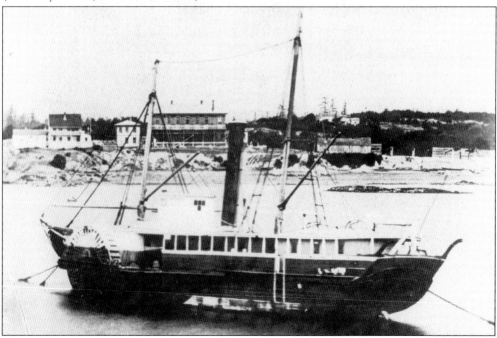

**SAILING AND STEAMSHIP BEAVER.** The Hudson's Bay Company ship *Beaver*, shown here in Victoria in the 1880s, is well known as the first steamship on the Pacific coast and in Puget Sound. However, few people are aware that in 1836 she arrived in the Pacific Northwest from England as a square-rigged sailing ship before her side-wheel paddles were installed and the steam engine became operational. Maritime historian Jim Gibbs has noted that the *Beaver* "qualifies as one of the early square-riggers to come to the West Coast." (Courtesy WSHS, No. 1943.42.25803.)

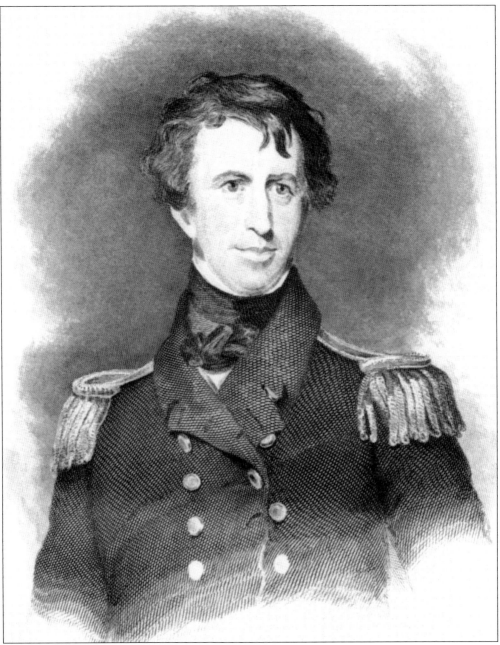

**FIRST AMERICAN EXPLORER.** Under the original Congressional authorization when John Quincy Adams was president, in 1841 U.S. Navy Lt. Charles Wilkes led the first U.S. exploration of the Pacific Northwest, including Puget Sound. The seven-ship fleet and crews of the U.S. Exploring Expedition (U.S.Ex.Ex.) probed areas of the sound uncharted by Capt. George Vancouver and produced a comprehensive map that remains the basis for those used today for inland vessel navigation. (Courtesy WSHS, Curtis No. N507.)

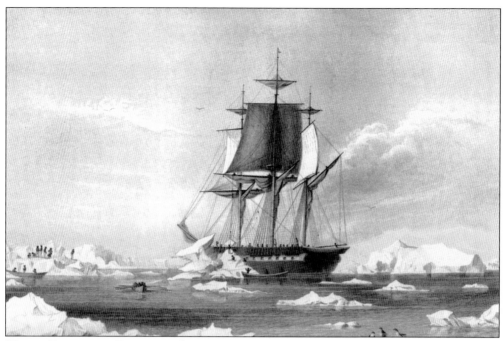

**WILKES EXPEDITION FLAGSHIP.** The USS *Vincennes*, a navy sloop-of-war, was the flagship of the Wilkes expedition. This illustration shows the *Vincennes* in Antarctica, one of the expedition's destinations during its four-year voyage to explore the Pacific Ocean, including the South Pacific Islands, Hawaii, and the U.S. Pacific Northwest. (Courtesy WSHS, *Wilkes Exploring Expedition Narrative, Vol. II.*)

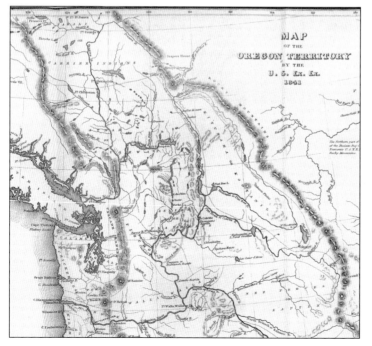

**WILKES MAP OF PUGET SOUND AREA.** Wilkes Expedition scientists, cartographers, and illustrators also explored inland areas of the Pacific Northwest and, as a result, produced excellent, detailed maps. These maps of the land and waters of what was in 1841 the U.S. Oregon Territory and surrounding area became essential planning tools for the subsequent settlement and growth of the region. (Courtesy WSHS, *Wilkes Narrative, Vol. IV.*)

# *Two*

# FROM EXPLORATION TO EXPANSION
## 1850–1893

Among the important early developments within the Pacific North region was the establishment of the Hudson's Bay Company (HBC), a British trading and merchandising enterprise. The HBC supplied the region's basic commercial and settler product needs beginning in 1821 through the international agreement creating the United States–Canada border at the 46th parallel in 1836. The company continued its commercial activities until American settlers dominated the Pacific Northwest in 1860, at which time it withdrew its operations to Victoria, British Columbia.

An essential means of transportation linking HBC operations on the Columbia River to Puget Sound and British Columbia was the steamship *Beaver*, the first steamer in the region. While steam engine–powered vessels first appeared in the Pacific Northwest during this period and larger steamships began operating in the mid-1880s, the large majority of the cargo fleet was dominated by tall sailing ships. During this half-century, square-, fore-, and aft-rigged sailing ships were the maritime economic mainstay of the rapidly growing Puget Sound area.

The California Gold Rush in 1849 helped spark this rapid development. The resulting need for food, lumber, coal, and other supplies from the Pacific Northwest forged active commercial links between California and Washington. Before roads and rails, the large, square-rigged ships and smaller coastal schooners were the connectors of commerce on the waterways along the Pacific Coast and throughout Puget Sound. And they helped turn the Puget Sound area's natural resources into rapidly growing maritime and other commercial enterprises that fueled the region's expansion.

Maritime commerce on the Pacific Coast during the 1800s was significant. As historian James Hitchman noted, it helped "change the area from one of the least important to one of the most important trading regions in the world."

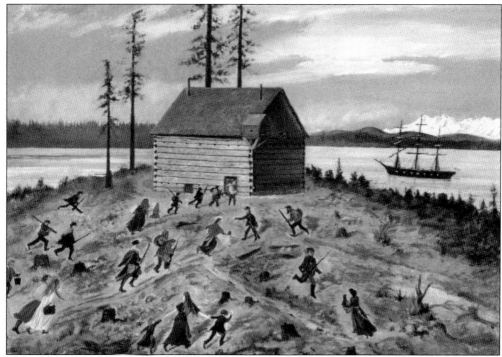

**BATTLE OF SEATTLE PAINTING.** Later in her life, Emily Inez Denny, daughter of early Seattle settler David Denny, painted this scene depicting the 1856 historical incident commonly called the battle of Seattle. It shows her interpretation of settlers running toward the city's blockhouse in anticipation of a threatened attack by Salish residents and in the background the U.S. Navy ship *Decatur* in Elliott Bay. (Courtesy MOHAI, MP 1955.921b.)

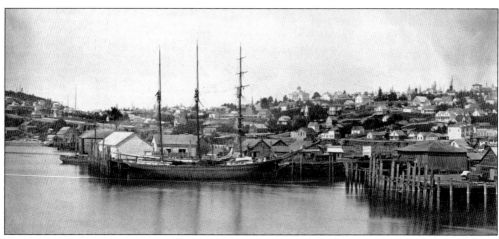

**SEATTLE WATERFRONT SCENE, 1880.** A three-mast barkentine—square-rigged on the foremast only—is shown moored on the Seattle waterfront in 1880 at Yesler's Wharf, today part of the Washington State Ferries Terminal on Alaska Way. The city's early houses are seen on the slope of the hill and, at the top, the first building of the University of Washington. (Courtesy UW Libraries, Special Collections, Hester No. 10059.)

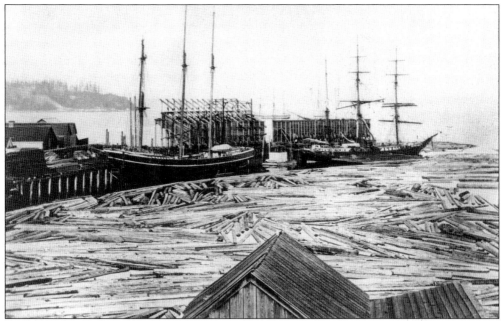

PIONEER LUMBER MILL. With stored logs in the foreground awaiting milling, this 1878 photograph shows a three-mast schooner (left) and a three-mast bark moored at the Yesler Mill to load finished lumber. A bark is a three or more mast sailing ship with the forward masts square rigged, and the aftermost mast with fore- and aft-rigged sails. During this period, finished lumber from this and the Washington Territory's other mills was shipped down the Pacific coast to California, as well as throughout the world. (Courtesy Puget Sound Maritime Historical Society, Seattle, No. 1741-5.)

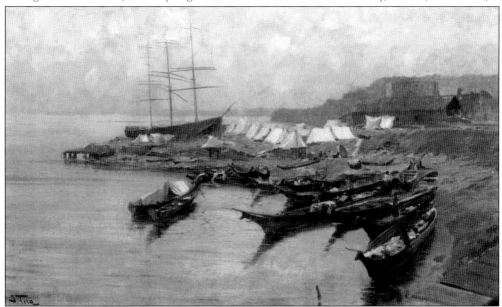

NATIVE SALISH CAMP, SEATTLE. A painting depicts a common early Seattle waterfront scene: an encampment of Salish natives with their tents and canoes. The coexistence of native canoes and a square-rigged ship portrays the early confluence of native and settler cultures in the Puget Sound region. (Courtesy MOHAI, No. MP 128217.)

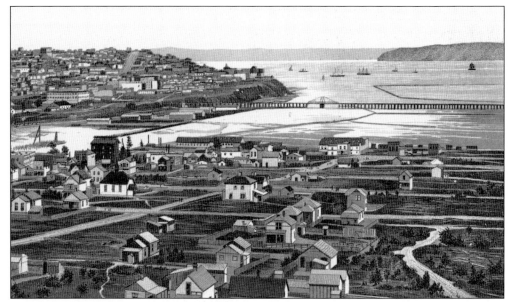

**EARLY TACOMA WATERFRONT AND UPLANDS.** Taken from a souvenir promotional booklet designed to attract new residents, an 1889 illustration shows Tacoma's early downtown waterfront with sailing ships anchored in Commencement Bay in the background. Washington, which had been a territory since 1853, became the 42nd state in 1889 and continued its rapid growth. (Courtesy Roger and Carolyn Erickson.)

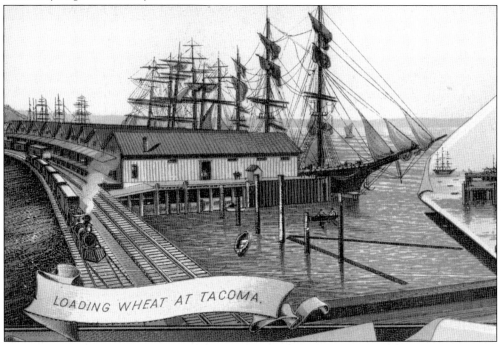

**SQUARE-RIGGERS LOADING WHEAT.** Another 1889 illustration from a Tacoma promotional booklet shows square-rigged ships taking on cargoes of sacked wheat at the early waterfront warehouses east of Old Tacoma. Flour mill structures later replaced these buildings; the wharf is still in use today as the Sperry Ocean Dock. (Courtesy Roger and Carolyn Erickson.)

18

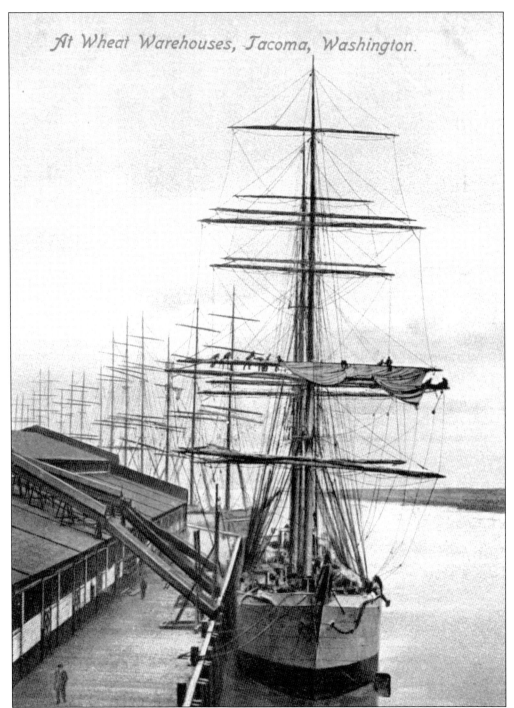

At Wheat Warehouses, Tacoma, Washington.

**NEW WAREHOUSES WELCOME TALL SHIPS.** In 1900, the Northern Pacific Railroad's real estate subsidiary, Northwestern Improvement Company, opened the first of its heavily promoted "longest wheat warehouse" complex on Tacoma's City Waterway. In this postcard version of a much-photographed scene, square-rigged ships await their cargoes of wheat and other grain for shipment throughout the world. (Courtesy Roger and Carolyn Erickson.)

**SHIPS LOADING AT TACOMA MILL.** The Tacoma Mill Company was built in 1869 and was owned by San Francisco businessman Charles Hanson and John W. Ackerson. It was located in Tacoma's Old Town. In 1902, it produced 79 million board feet of lumber for markets worldwide. This panorama photograph taken the same year shows several schooners and a square-rigger (far right) loading lumber with their sterns tied to the mill's dock. Many of the sailing ships were

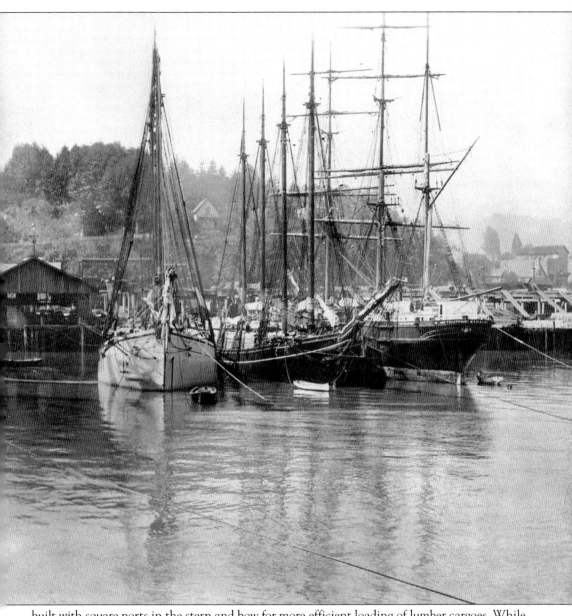

built with square ports in the stern and bow for more efficient loading of lumber cargoes. While today the mill site is Tacoma's Jack Hyde Park, the Sperry Ocean Dock immediately to the east is still used for mooring large, oceangoing, military support ships. (Courtesy Ron Karabaich, Old Town Photo.)

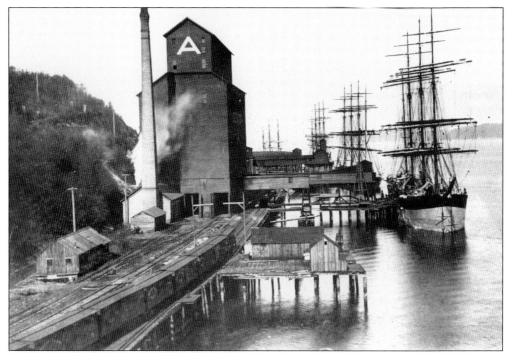

**TACOMA'S GRAIN ELEVATOR A.** One of the early landmarks of Tacoma's developing waterfront in the late 1880s was wheat elevator A. Built by the Puget Sound Flouring Mill in 1889 and later purchased by Sperry Mills, major square-rigged tall sailing ships from around the world loaded flour from its dock. Modern grain cargo ships still call at this improved elevator and dock complex, now operated by TEMCO, the Tacoma Export Marketing Company. (Courtesy WSHS, No. Tac Wat 120.)

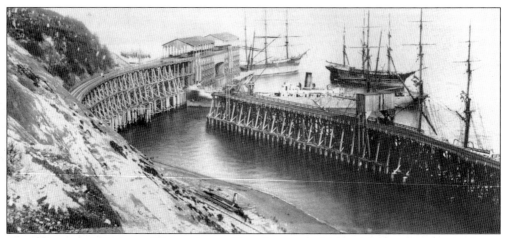

**COAL BUNKERS, TACOMA WATERFRONT.** Two three-mast barks and a steam ship are shown loading coal at the Northern Pacific's Tacoma bunker facility in this photograph taken in the late 1880s. The bunkers were a common waterfront sight until the market for coal ended in the 1920s and early 1930s, and the structures were replaced by wharves, warehouses, and flour mills. (Courtesy WSHS, No. Tac Wat 75.)

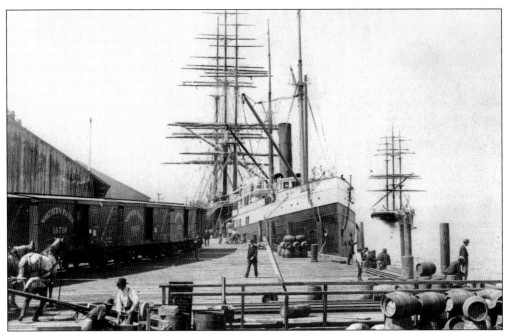

RAILS TO SAILS. The widely known "Rails to Sails" phrase is illustrated graphically in this late-1880s photograph of railroad boxcars on the terminal wharf adjacent to both steam and sailing ships. Wheat and other grain grown in eastern Washington State was transported by rail across the Cascade Mountains to the awaiting ships in Tacoma and other Puget Sound ports. (Courtesy WSHS, No. Tac Wat 74.)

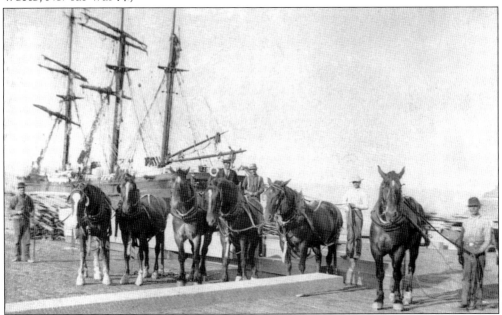

HORSEPOWER AND SAIL POWER. A photograph of the Tacoma Mill Company wharf at the end of the 1800s shows teams of horses and their handlers used to load ships such as the bark in the background. Lumber and other bulk cargo was moved across the docks by horse-drawn wagons and onboard the awaiting cargo vessels. (Courtesy WSHS, No. Tac Wat 37.)

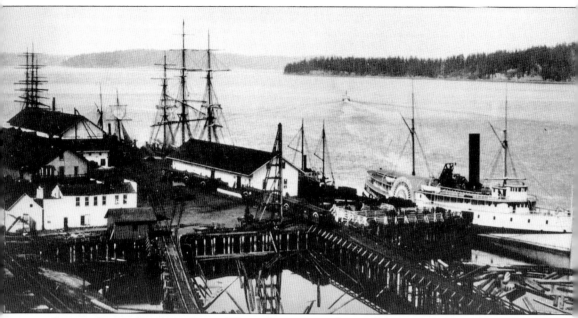

**Sail to Steam-Powered Ships.** The early transition from wind-powered sailing ships to steam engine–powered vessels is depicted in this 1886 photograph. A side-wheel steamer (right), three-mast full-rigged ship, and a smaller square-sail brig are moored at the terminal wharf north of the developing New Tacoma area with Browns Point in the background. A brig is a two-mast sailing vessel with both masts square-sail-rigged. (Courtesy WSHS, No. Tac Wat 85.)

# Three

# TRANSITION
# AND EVOLUTION
## 1894–1929

The new technology of the first and second Industrial Revolution eras brought significant change to the maritime economic environment worldwide. The large cargo and passenger-carrying ships once powered by wind and sail evolved into wood-, coal-, and oil-fired steamships, and then petroleum-fueled water vessels. And these major technological developments were felt in the Pacific Northwest and Puget Sound. Older sailing vessels were purchased on the East Coast and sailed to the West Coast, and, in turn, newer, faster, and more efficient engine-driven cargo ships eventually replaced them.

Maritime historian Gary White's research reveals that in 1880 sailing ships had about three-quarters of the world's shipping cargo capacity and steam-powered vessels the remainder. By 1910, only 30 years later, this situation had reversed, and sailing ships provided only one-fourth of the total.

Reporting another aspect of this downward trend, maritime historian Michael Mjelde noted that, early in the 20th century, the U.S. commissioner of navigation stated that the number of square-rigged ships under the American flag declined 46 percent between 1894 and 1902.

A sailor and authority on the last days of the great sailing ships, Capt. Alan Villiers estimated that in 1905 there were 3,500 deepwater square-riggers sailing the world. However, noted in White and Mjelde's research, this impressive total declined rapidly during the initial decades of the 20th century.

The dramatically reduced maritime role for sailing ships was reflected in the Pacific Northwest and continued through World War I and the raucous decade of the 1920s. A well-known West Coast maritime historian, John Lyman, estimated that about 10,000 ships from Atlantic ports and Europe had rounded Cape Horn in South America bound for San Francisco during the period from 1850 to 1920. However, the opening of the Panama Canal in 1914 changed this pattern significantly; cargo hauling aboard sailing ships continued to decline, and the Depression of 1929 sounded the death knell for the big square-riggers.

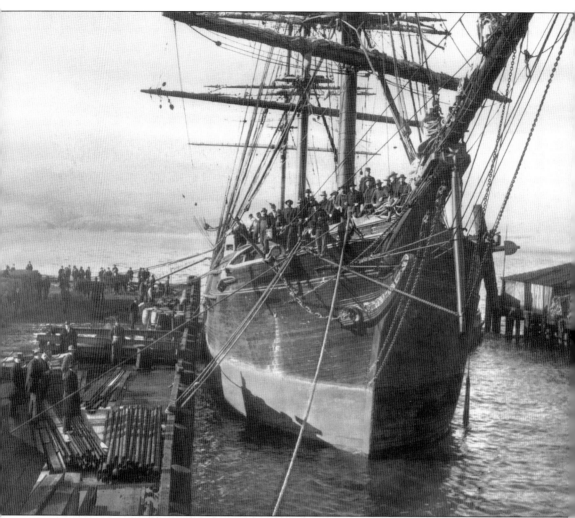

**ALASKA GOLD RUSH BOUND.** In a classic photograph by Asakel Curtis, eager Alaska-bound passengers crowd the bow of the square-rigger *Lucille* prior to its departure from the Seattle waterfront around 1898 during the Klondike gold rush. Built in Maine in 1874, the *Lucille* was one of many sailing and steam ships that carried would-be miners to the Alaska gold fields, few of which found fame and fortune. (Courtesy MOHAI, No. 2002.3.459.)

**NEW TACOMA WATERFRONT, 1894.** A barkentine steam ship is anchored on the waterfront in this 1894 photograph of the developing New Tacoma downtown area. The image was taken from the tower of the new city hall, built a year earlier, and more than a century later, it is still one of the city's most widely known landmarks. (Courtesy WSHS, No. 2005.0.423.)

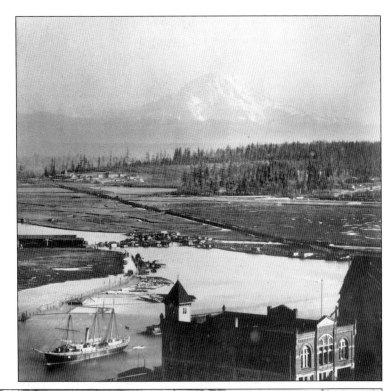

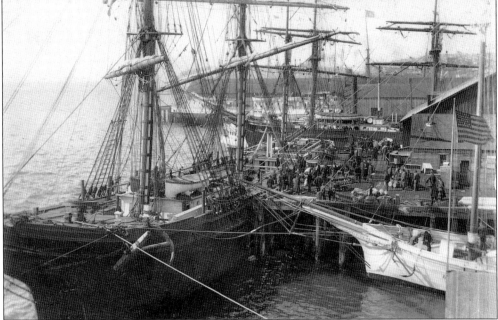

**SEATTLE WATERFRONT, LATE 1890s.** The bustling Seattle waterfront is shown in this photograph from the late 1890s with square-riggers and a schooner berthed at right and people crowding the dock. This was the Alaska gold rush period when passengers were flocking to the waterfront to find ships bound for the Klondike. (Courtesy Jefferson County Historical Society, Port Townsend, Washington, No. 2.1.)

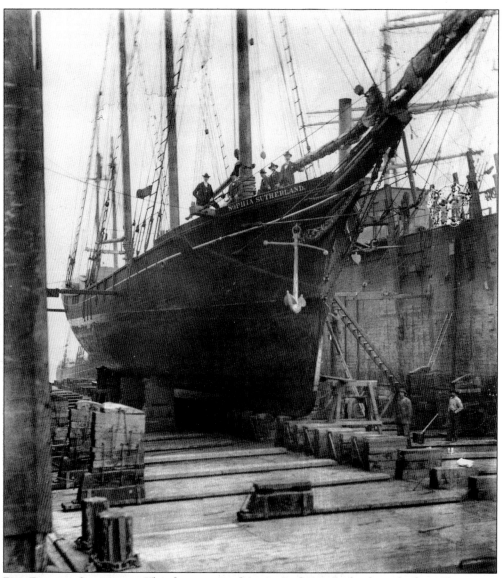

**DRY-DOCKED SCHOONER.** The three-mast schooner *Sophia Sutherland* was built in Tacoma in 1889. She became famous for the 1893 voyage author Jack London took aboard her to the Bering Sea. During that voyage, London gathered information for his novel *The Sea-Wolf*. The schooner met an unfortunate end in Alaska in 1900, wrecked ashore after a storm. (Courtesy San Francisco Maritime National Historical Park, No. B4.164nl, Louis Weale Collection.)

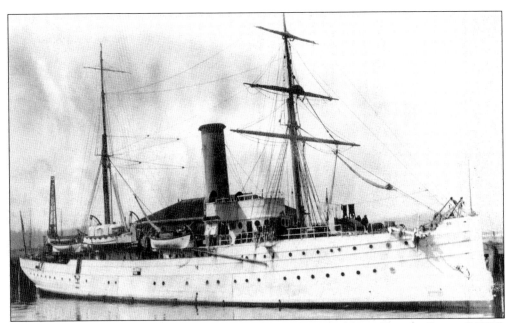

**SAIL-RIGGED REVENUE CUTTER.** By the 1870s, cutters of the United States Revenue Service (USRS) serving Puget Sound, the Pacific Northwest, and Alaska were powered by steam engines, but they were also rigged for sail. The USRS *Manning*, shown here, was square-rigged on its foremast for emergency sail use in Alaskan waters. (Courtesy Coast Guard Museum Northwest, No. 77.5/120.)

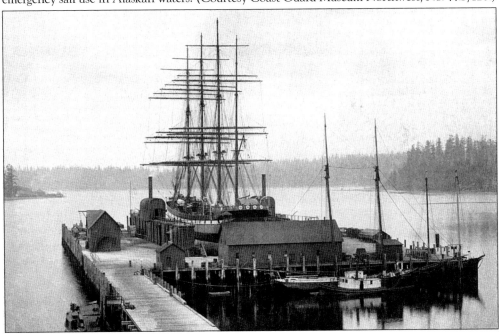

**DRY DOCK AT DOCKTON.** The 326-foot-long, British four-mast steel bark *Olivebank* dominates this dry-dock scene in Quartermaster Harbor in 1898, four years after the square-rigger was built in Scotland. The well-protected, steam-powered floating dry dock and maintenance facility at Dockton was a favorite of ship owners at the end of the 1800s and early 1900s. (Courtesy UW Libraries, Special Collections, Van Orlinda No. 19277.)

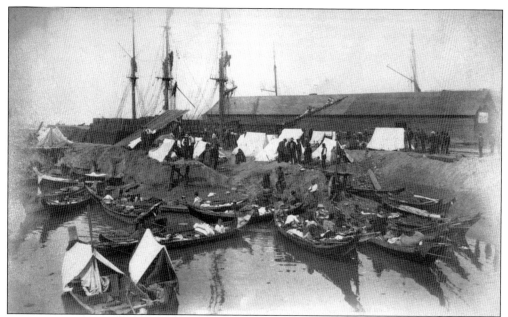

SALISH CANOES AND TALL SHIP, SEATTLE. A cross-cultural view of the Seattle waterfront in the late 1890s shows a native Salish encampment with canoes and in the background the three masts of a sailing ship. Today, more than a century later, the unique maritime cultures and traditions of both native and early explorers and settlers are increasingly recognized, respected, and honored. (Courtesy MOHAI, No. SHS 6128.)

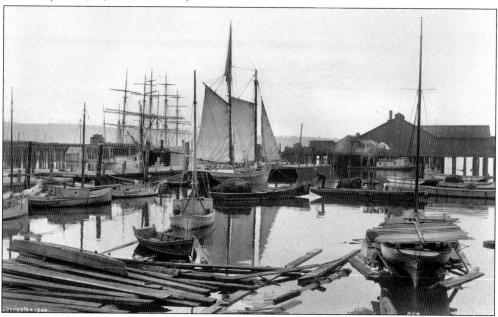

SERENE WATERFRONT SCENE, 1901. This idyllic Seattle marine scene at the beginning of the 20th century shows a diversity of watercraft types moored behind a protective seawall on the waterfront. A small, two-mast schooner with its sails raised is shown at center, square-rigged ships are in the background at left, a steam tug at the wharf building is on the right, and several small craft are visible throughout the moorage. (Courtesy MOHAI, Wilse No. 88133.136.)

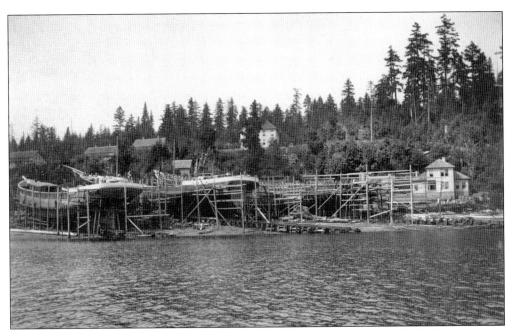

TALL SHIPS UNDER CONSTRUCTION. Three wooden schooners at various stages of construction are shown in a 1902 photograph taken at the second Hall Brothers Shipyard at Port Blakely on Bainbridge Island. Between 1880 to 1903, the widely known and respected shipbuilding company built 77 wooden ships, sail and steam, at the yard. (Courtesy UW Libraries, Special Collections, Hester No. 10150.)

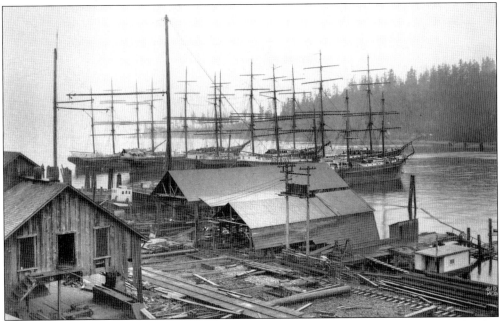

SHIPYARD AND SQUARE-RIGGERS. Port Blakely was a center for both shipbuilding and lumber milling on Puget Sound in the late 19th and early 20th century. Hall Brothers dominated the shipbuilding industry of the period, and the Port Blakely Mill Company was a leading manufacturer of lumber. (Courtesy PSMHS, No. 4636-39.)

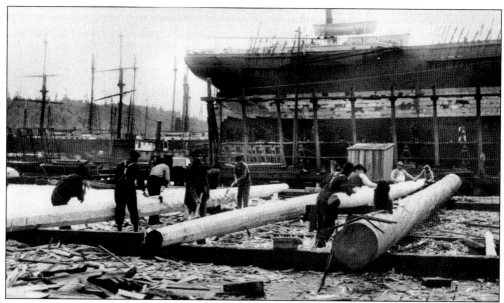

**FROM TREES TO TOPMASTS.** Before the turn of the 19th century, workers at Hall Brothers Shipyard shaped massive logs into masts or spars for schooners and other ships. Straight-grained Douglas fir trees from nearby forests were milled and converted into spars and yards, or crosstrees, for the nearby ship on the marine railway. Traditional sailing-ship spars are still made today in Washington State, but on a giant lathe at the Grays Harbor Historical Seaport in Aberdeen on the coast. (Courtesy PSMHS, No. 1064-12.)

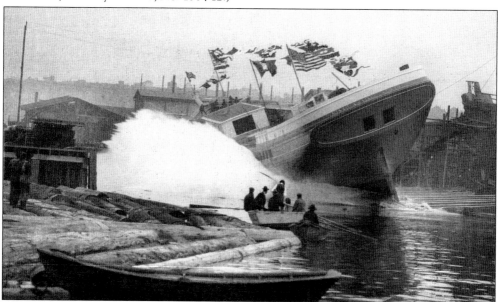

**WALL OF WATER.** While spectators in skiffs watched safely astern, the side launch of the four-mast schooner *Minnie A Craine* at Seattle's Moran shipyard in 1900 caused a spectacular water spray. Under the Moran name, the shipyard built more than 60 vessels of various types from 1897 until 1914, including the battleship USS *Nebraska*, but only two sailing ships—the *Craine* and the four-mast barkentine *James Johnson* in 1901. (Courtesy UW Libraries, Special Collections, Curtis No. 1470.)

HEAVY HAUL OUT. Two vessels, the Bellingham-built, four-mast schooner *Sehome* and the steam yacht *Davy Jones*, are hauled out on the marine railway at the Hall Brothers Shipyard at Eagle Harbor. In 1903, Hall Brothers moved their shipbuilding operation to Madrone, south of Port Blakely on Bainbridge Island. The city was renamed Winslow in honor of Winslow Hall, the brother who established the company in 1873. (Courtesy PSMHS, No. 1064-9.)

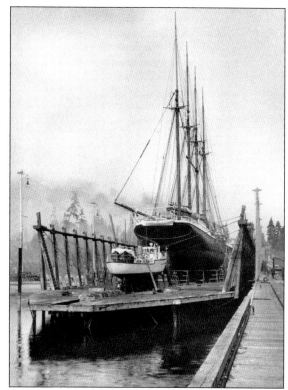

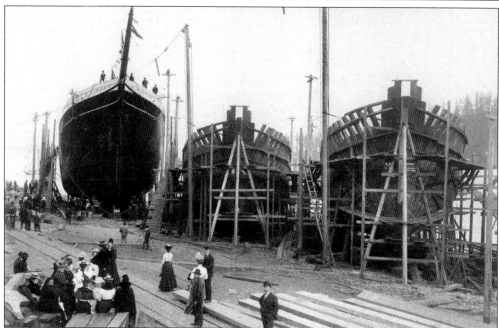

NEW SCHOONER LAUNCHING. Crowds dressed up for the occasion gather to celebrate the launching of the schooner *H. K. Hall* (left) at the Hall Brothers Port Blakely shipyard in 1902. Construction on the hulls of the two schooners to the right of the *H. K. Hall* is well underway. (Courtesy UW Libraries, Special Collections, Hester No. 10450.)

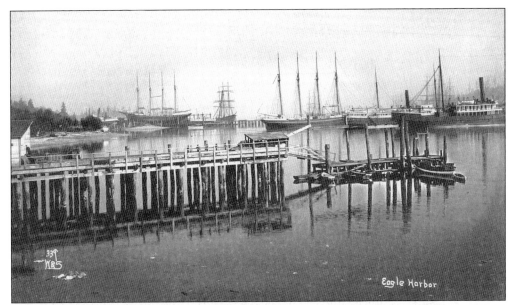

**EAGLE HARBOR PANORAMA.** The Hall Brothers Shipyard at Eagle Harbor is shown at left in this serene 1909 photograph of the harbor. At Winslow, its third site, the relocated shipbuilding company operated for more than a decade until 1916 when it was sold and Hall Brothers went out of business. (Courtesy Rob Paterson.)

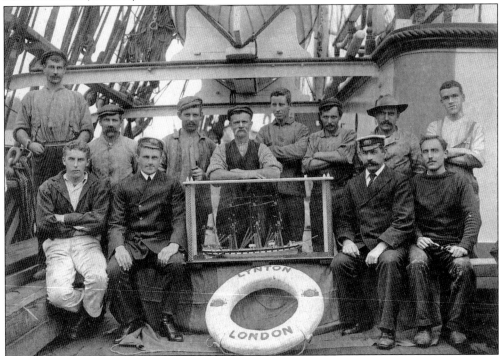

**MODEL SQUARE-RIGGER CREW.** Crew members of the four-mast, steel, British bark *Lynton* proudly display a glass-cased model of their ship during a 1904 port call in Puget Sound. The full-size version of the ship was 299 feet long, and the square-rigger was built in Liverpool, England, in 1894. (Courtesy UW Libraries Special Collections, Hester No. 3181.)

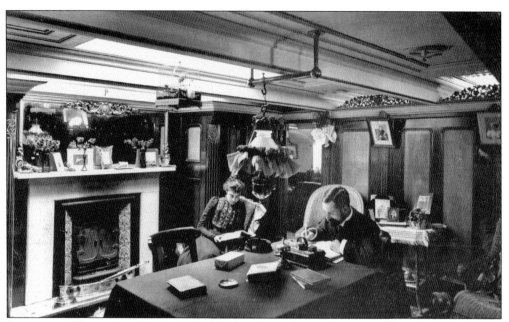

**SHIPBOARD WORK AND LEISURE.** With light coming in from the deck above, *Lynton* captain Edward Gates-James is shown at work in his cabin in 1905 while his wife relaxes with a book. Captain or shipmaster's cabins, also known as saloons, were comfortable, well furnished, and decorated with familiar mementos to ease being away from home during long voyages. (Courtesy MOHAI, No. 1996.7.13.)

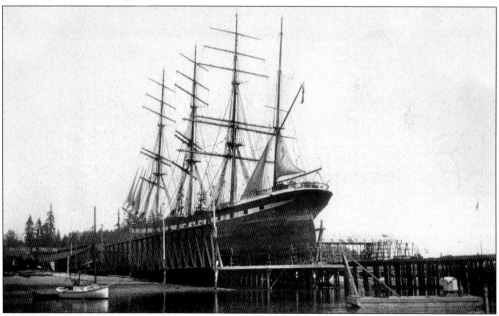

**HAULED AND HIGH MASTED.** The bark *Lynton* is shown high, dry, and hauled out at the Hall Brothers Marine Railway and Shipyard at Eagle Harbor in 1906. After a 23-year career carrying cargo from its home port in Liverpool, England, to India, the United States, Australia, and other countries, the imposing tall sailing ship was sunk off the coast of Ireland by a German submarine in 1917 during World War I. (Courtesy UW Libraries, Special Collections, Hester No. 318.)

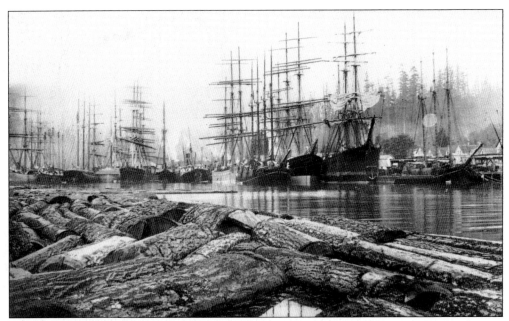

**TALL SHIPS–BOUND TIMBER.** Rafted logs are stored before being milled into lumber at the Port Blakely Mill in the background. This Wilhelm Hester photograph, taken in 1900, shows more than 10 square-rigged ships and schooners moored stern to the dock to load lumber from the mill. Annually, the mill produced millions of board feet of lumber shipped to ports worldwide. (Courtesy UW Libraries, Special Collections, hester No. 10155.)

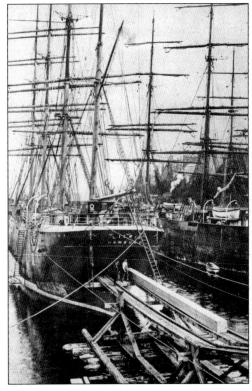

**TALL TIMBER ABOARD.** The German four-mast bark *Eilbek* is shown loading a massive Douglas fir beam at the Port Blakely Mill in the early 1900s. This photograph was used on several postcards of the period, one of which described the timber—measuring almost 2 feet square by 79 feet long—as fictional lumberjack Paul Bunyan's "toothpick." (Courtesy Rob Paterson.)

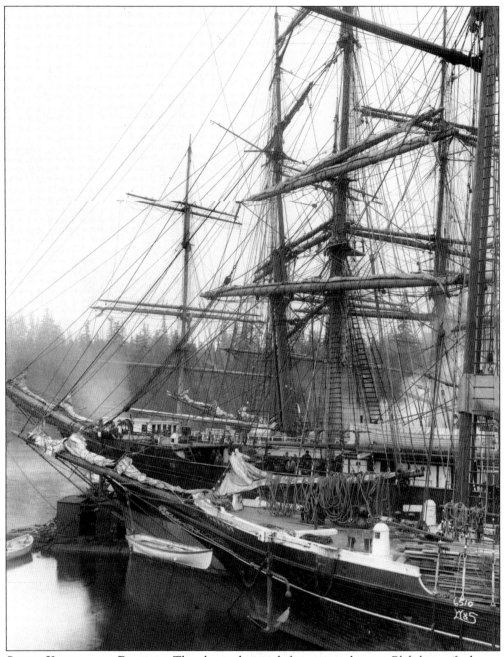

**Spars, Yards, and Rigging.** The classic designed, four-mast schooner *Blakely* is rafted next to the German bark *Thalassa* in this photograph taken at Port Blakely in the early 1900s. The *Blakely* was built by Hall Brothers Shipyard in 1902 for the Port Blakely Mill Company. It was sold for use in the Gulf of Mexico trade to an owner in Alabama in 1919 and subsequently to Florida owners in 1932 before it sunk off the coast of Cuba in 1933. (Courtesy PSMHS, No. 4636-27.)

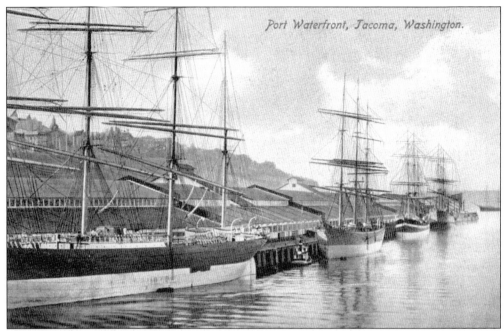

**WHEAT WAREHOUSE SHIPS.** With square-rigged ships at the docks, a postcard depicting Tacoma's so-called mile-long series of wheat warehouses helped promote the proud city. After the Northern Pacific Railroad selected Tacoma as its Puget Sound terminus in 1873, the railroad's land development company began construction in the late 1800s of what was actually a half mile of connected rails-to-sails cargo warehouses to serve the expanding international grain trade. (Courtesy Roger and Carolyn Erickson.)

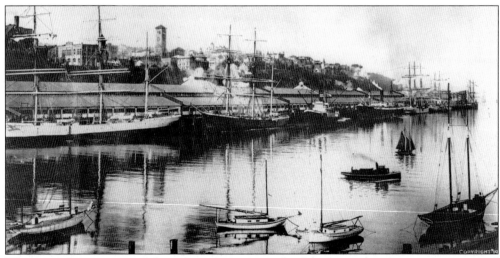

**WATERWAY REFLECTIONS.** A large fleet of square-rigged sailing ships, steamships, and recreational boats is seen in this 1908 photograph of City Waterway on Tacoma's downtown working waterfront. The name of the historically busy channel was changed in 1989 to the Thea Foss Waterway, to honor the cofounder a century earlier of what is now Foss Maritime, one of the nation's leading tugboat and marine services companies. (Courtesy WSHS, No. Tac Wat 2.)

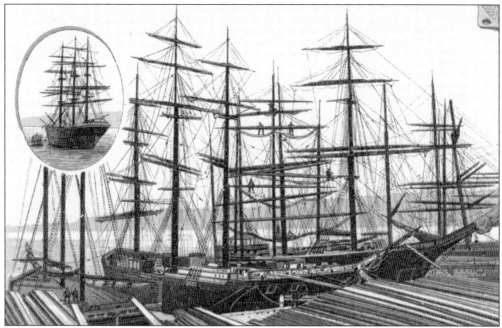

**MASSED TALL SHIPS.** Adapted from many photographs of the same site, this 1989 souvenir booklet engraving showed massed square-rigged ships loading lumber at the St. Paul and Tacoma Lumber Company on the Tacoma tide flats. The company was a significant producer of finished lumber, milling more than 121 million board feet in 1902. (Courtesy Roger and Carolyn Erickson.)

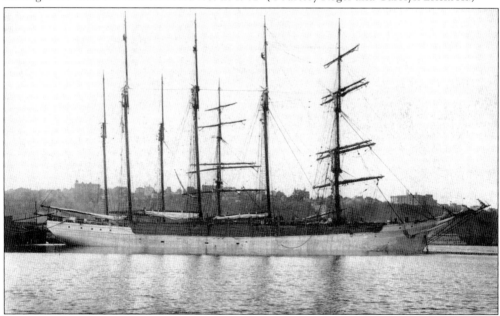

**ART TO ACTUALITY.** From souvenir booklet art to reality, this 1904 photograph showed the four-mast barkentine *Thomas P. Emigh* loading lumber at the St. Paul and Tacoma Lumber Company. The *Thomas P. Emigh* was one of three major tall ships built in Tacoma in the late 1800s and early 1900s. The sleek vessel held many voyage speed records during her more that 30 years in the coastwise and Hawaiian cargo trade. (Courtesy UW Libraries, Special Collections, Hester No. 318.)

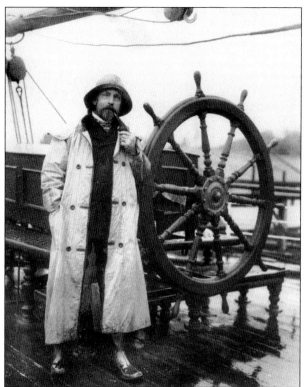

**CLASSIC CAPTAIN.** The familiar maritime photograph of Capt. Alex Teschner posed at the wheel of the three-masted German bark *Pera* was taken in 1901 by Wilhelm Hester at Port Blakely. Captains whose ships visited Puget Sound found that their canvas oilskin coats and foul-weather hats, normally used during deepwater voyages, provided protection from the region's constant rain. (Courtesy MOHAI, Hester No. 1996.7.225.)

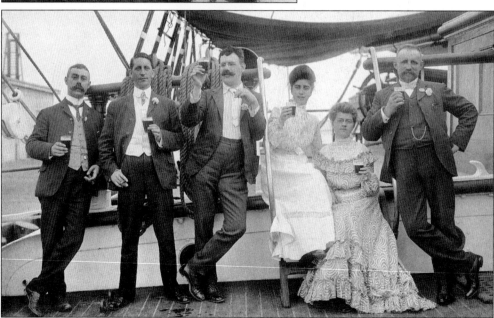

**FRENCH FRIVOLITY.** Another Wilhelm Hester photograph, taken in 1902, revealed that life aboard tall ships calling at Puget Sound ports was not all work. During some leisure time while loading a cargo of grain in Tacoma, a well-dressed group of crew members and visitors posed on the deck of the three-mast French bark *Lamoriciere* built in 1895. (Courtesy San Francisco NHP, Hester Collection, No. P51.12,456nl.)

**ONBOARD FAMILY PORTRAIT.** To lessen the effect of long periods away from home, captains sometimes took their wives and children with them aboard their ship. Here Capt. A. McKinnon, his wife, and young son are shown on the four-mast British bark *Kinrosshire* at Tacoma in 1903. (Courtesy MOHAI, Hester No. 1996.7.79.)

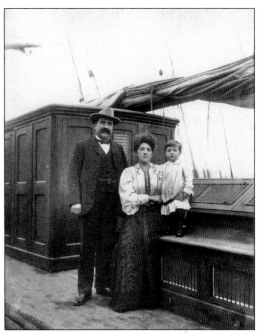

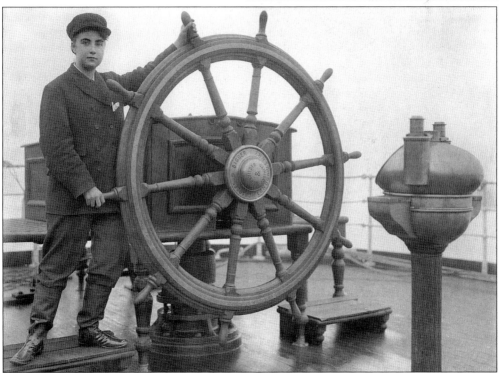

**DAUGHTER ON DECK.** Older children of tall sailing ship captains also joined their fathers for long-distance cargo voyages on the world's oceans. The daughter of Captain Rothers, master of the three-mast, full-rigged British ship *Dimsdale*, struck this strong pose at the wheel of the vessel as it loaded cargo in Puget Sound in the early 1900s. The sailing vessel was built in 1890 in Derry, England. (Courtesy San Francisco NHP, Hester Collection, No. P50.12,359nl.)

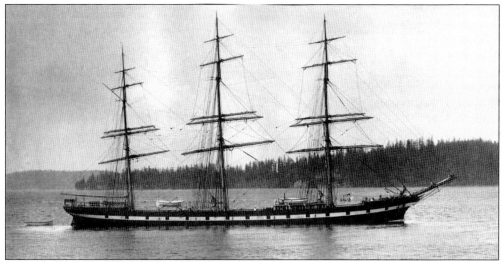

**FLOTTBEK IN TACOMA, 1904.** The German full-rigged ship *Flottbek* is shown at anchor in Commencement Bay about 1904. Built in 1891 for the Hamburg Hansa Line, the name *Flottbek* has appeared on five of the more-than-a-century-old shipping company's vessels, the most recent of which was a coastal and transatlantic container feeder ship launched in 2005. (Courtesy UW Libraries, Special Collections, Hester No. 318.)

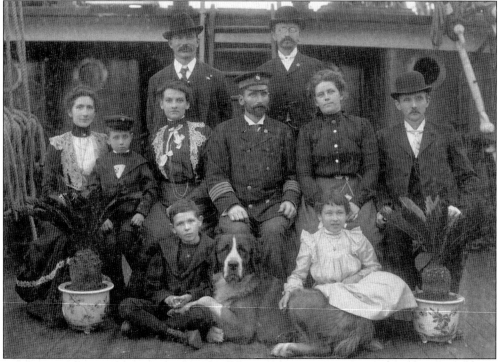

**CAPTAIN, FAMILY, AND FRIENDS.** *Flottbek* captain Georg Cringler, his family, friends, and Saint Bernard dog are shown in this 1905 Hester photograph taken in Tacoma. Known as a hard-driving master to his crew, Cringler sometimes took his family with him as he sailed the world, and he hosted German relatives and friends during his ship's various port calls. (Courtesy UW Libraries, Special Collections, No. 10390.)

**SAILORS ALOFT.** Crew members are posed on the shrouds of an unidentified tall sailing ship after climbing the rigging. To add to the visual impact of the image, photographer Wilhelm Hester also positioned one crewman among the drying sails (center, right) and four others on the ship's boats. (Courtesy Rob Paterson, from Williamson Marine Photo Shop.)

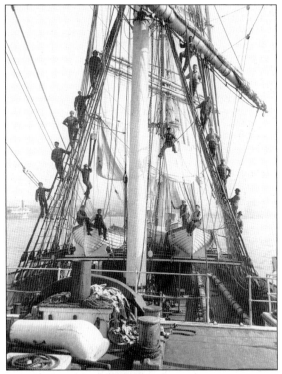

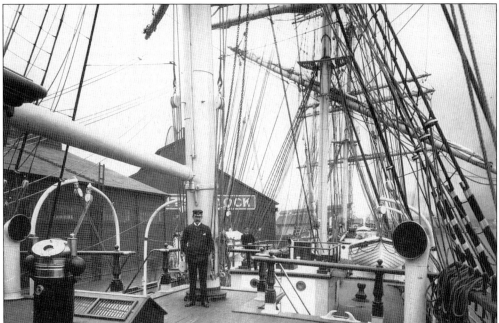

**SHIPSHAPE IN SEATTLE.** A proud captain, G. Harrison, is shown at the base of the mizzenmast of the three-mast British bark *Eva Montgomery* while moored on the Seattle waterfront in the early 1900s. Along with the USS *Constitution*, the British bark *Lynton*, and many other vessels, the *Montgomery* featured a striking black hull, a white stripe below its gunwales, and false gun ports, a traditional sailing ship design. (Courtesy San Francisco Maritime NHP No. F9.12,452.)

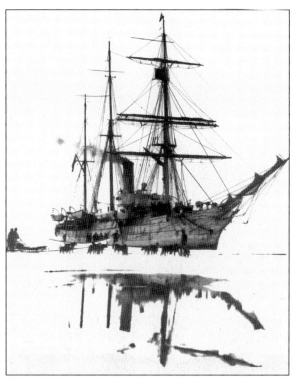

**REVENUE CUTTER BEAR ICEBOUND.** Launched in 1874 in Scotland, the USRS cutter *Bear* is shown surrounded by ice in Alaska during one of its 34 Bering Sea patrol cruises. Rigged as a barkentine with sails and also powered by a compound steam engine, the widely known cutter was based in Puget Sound during its long career, first in the Revenue Service and then with the Coast Guard from 1885 to 1929. (Courtesy Coast Guard Museum Northwest, No. 82.17/21.)

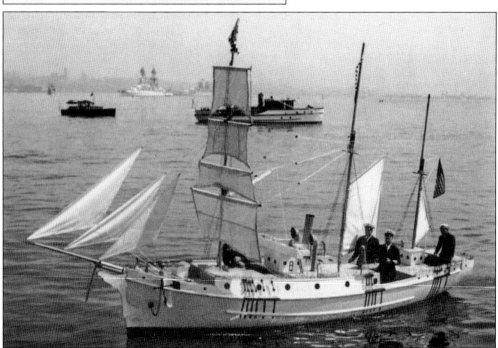

**SMALL BEAR ON PARADE.** A much smaller version of the legendary Coast Guard cutter *Bear*, with all sails flying proudly, appeared in a Fleet Week maritime celebration on the Seattle waterfront in 1938. The two chief boatswains, shown amidships, converted a standard whaleboat to create a reproduction of the famous cutter. (Courtesy Coast Guard Museum Northwest, No. 76.167/12.)

**SCHOONER UNDER SAIL.** This dramatic photograph shows the four-mast schooner *Susie T. Plummer* under almost-out full sail, forming an impressive bow wave or in mariners' terms, "With a bone in her teeth." Built in Maine in 1890 and brought to the Pacific Coast in 1904, the schooner met a tragic end when, on a 1909 voyage from Everett to California, it capsized off Cape Flattery with all 10 if its crew members lost. (Courtesy Jefferson County Historical Society, Port Townsend, Washington, No. 2.616.)

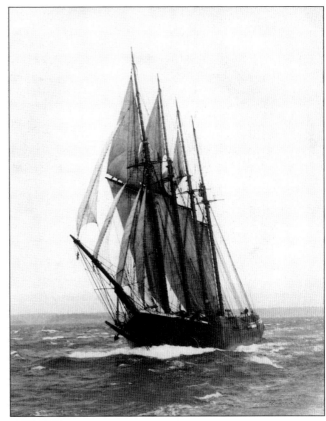

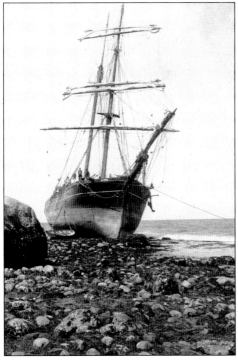

**BRIGANTINE ON THE BEACH.** In 1902, the small, two-mast brigantine *Tanner* ran aground and was abandoned on the beach south of Port Townsend. It was one of several sailing vessels that in 1866 had brought young unmarried women from San Francisco to Seattle to marry, settle, and raise families in the rapidly growing Puget Sound city. Organized by entrepreneur and pioneer Asa Mercer, the women were popularly known as "Mercer Girls." (Courtesy MOHAI, No. 1955.970.627.)

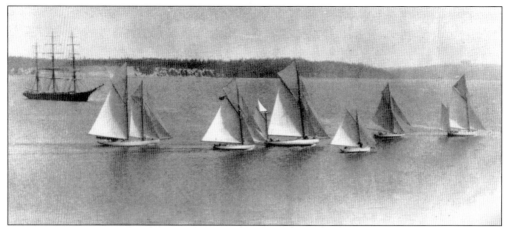

**TALL SHIP, SMALL SHIPS.** Both a working square-rigger (background, left), as well as a recreational schooner and other sailboats, are shown in this 1901 photograph of a sailing regatta on the Port Townsend waterfront. Today, a century later, this sailboat racing tradition continues through the Classic Mariners' Regatta sponsored annually by the Wooden Boat Foundation. (Courtesy Jefferson County Historical Society, Port Townsend, Washington, No. 2.201.)

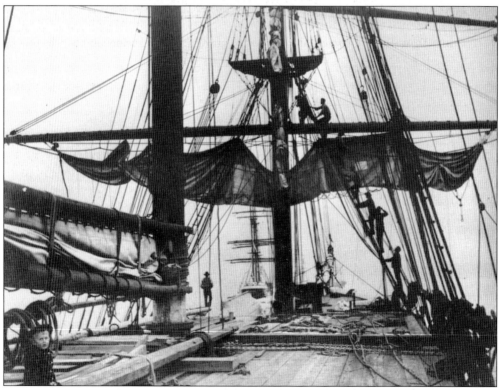

**SAILORS CLIMB THE SHROUDS.** In this image taken in the early 1900s by Port Townsend banker James G. McCurdy, also an accomplished photographer, square-rigged ship sailors climb the shrouds as a sail lashed to a yard dries amidst the rigging. A young H. W. "Mac" McCurdy is shown standing on deck (left corner) while accompanying his father during a visit to the unidentified ship. (Jefferson County Historical Society, Port Townsend, Washington, No. 2.619.)

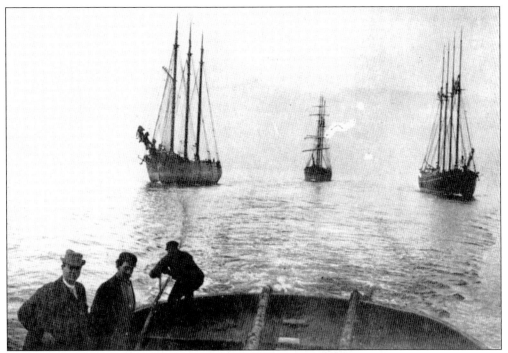

**TALL SHIPS TOW.** Tugboat owners always tried to maximize their business income by towing more than one sailing ship arriving at or departing from Puget Sound ports. The widely known steam engine–powered tug *Wanderer*, built in 1890 by the Hall Brothers at Port Blakely, is shown towing three sailing vessels, two schooners, and a barkentine near Port Townsend. (Courtesy Jefferson County Historical Society, Port Townsend, Washington, No. 2.262.)

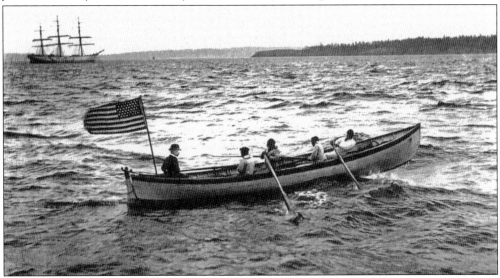

**SHIP AND SHIP'S BOAT.** With a U.S. Public Health Service doctor seated in the stern, the crew of a ship's boat rows away from the Port Townsend waterfront toward the anchored three-mast full-rigged ship in the background (left). Beginning in 1854, Port Townsend was the port of entry into Puget Sound and all ships had to undergo health inspections. (Courtesy Jefferson County Historical Society, Port Townsend, Washington, No. 2.727.)

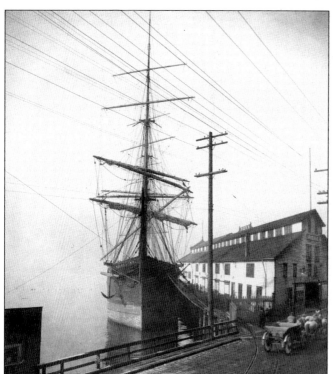

**SHIP AND SHORE SPARS.** The interesting similarity between tall sailing ship masts, or spars, and shore-side telephone poles is shown in this photograph of the full-rigged ship *A. J. Fuller*, berthed at a Seattle waterfront pier in the early 1900s. As the era of the commercial square-rigged ship was declining, the expansion of urban electrical and telephone technology was increasing rapidly. (Courtesy PSMHS, No. 5642-2.)

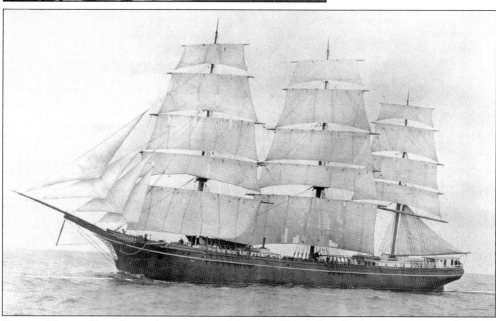

**FULLER UNDER FULL SAIL.** Among many Maine or Down East–built square-riggers, the *A. J. Fuller* was constructed in Bath in 1881. The 229-foot-long ship first brought cargo to San Francisco in 1881 and 18 years later was purchased by new owners in that city. In 1909, the *Fuller* was sold to Northwestern Fisheries Company of Seattle to be used in its Alaska salmon cannery business. In 1918, while anchored in Seattle's Elliot Bay in foggy weather, the ship was struck by a Japanese steamship, sank, and was a total loss. (Courtesy MOHAI.)

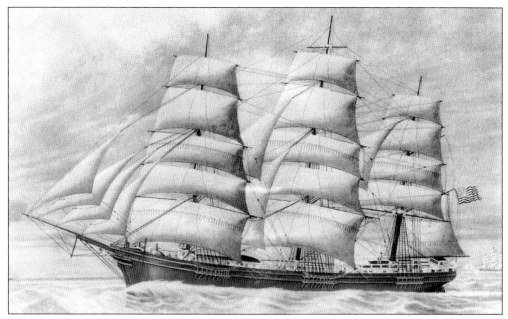

**GLORIOUS SHIP ILLUSTRATION.** This lithograph print shows the famous full-rigged ship *Glory of the Seas*, launched in 1869, under full sail on the high seas. This ship was the last of the famed clipper designs built by Donald McKay in East Boston. At the end of her active cargo-hauling life as a Cape Horner, the ship was operated out of San Francisco beginning in 1886. (Courtesy PSMHS.)

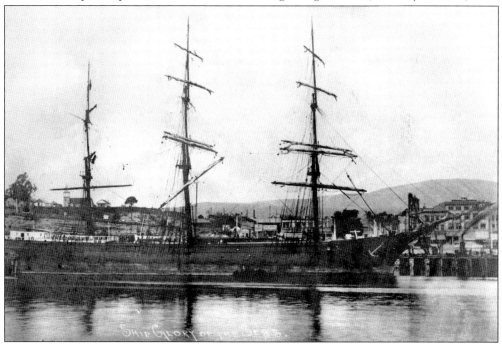

**IN-BOUND FROM BELLINGHAM.** The *Glory of the Seas* is shown on the San Pedro, California, waterfront in 1907 unloading a cargo of lumber from Bellingham. After being laid up for a few years in Puget Sound, she made a final voyage in 1910 to Alaska from British Columbia. The ship was bought in 1911 by Seattle owners for conversion to a floating fish cannery. (Courtesy PSMHS, No. 1028-5.)

GLORIOUS NO MORE. With all but one of her square-rig sail yards removed, the *Glory of the Seas* is shown as a cold storage in Alaska in 1915. With steam exhausting from her onboard refrigeration machinery, the once proud ship was later owned by the Glacier Fish Company and used as a cold storage barge. (Courtesy PSMHS, No. 1028-1.)

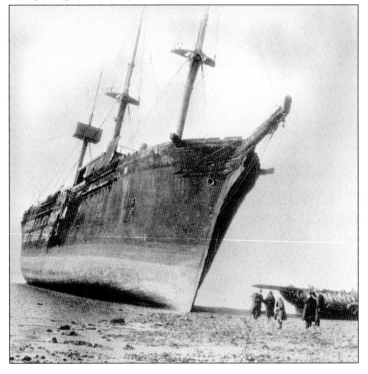

BEACHED FOR BURNING. After a glorious career sailing the high seas of the Atlantic and the Pacific, followed by a not-so glamorous life as a floating cannery and later a cold storage barge, the *Glory of the Seas* was beached in 1923 and set afire. A final effort to save the ship as a museum failed, and she was burned for her scrap metal value near Fauntleroy south of Seattle. (Courtesy PSMHS, No. 1028.)

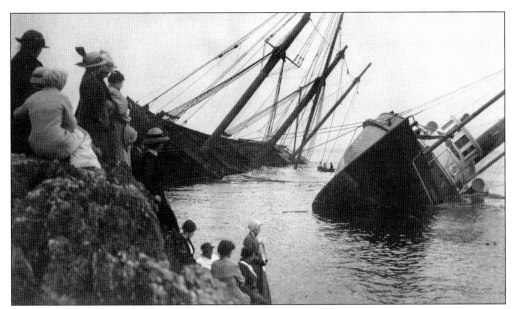

**WRECKED TALL SHIP AND TUG.** While many obsolete tall sailing ships in Puget Sound were burned at the end of their days, some were wrecked. Converted to a barge, the former three-masted, fully rigged ship *America*, built in 1874, is shown wrecked on the rocks at False Bay, San Juan Island, in 1914. Towed by the tugboat *Lorne*, the *America* and its cargo of coal were a total loss, but the tug was refloated, repaired, and returned to operation. (Courtesy PSMHS, No. 2628-2.)

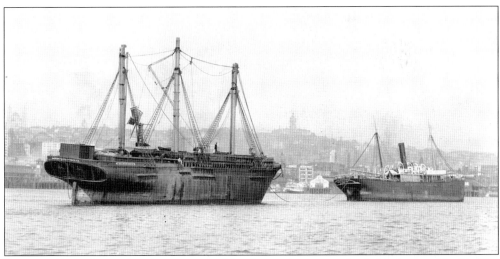

**DASHING DAYS OVER.** Another survivor of the clipper-ship era on the Atlantic coast, the *Dashing Wave* (left), built in Portsmouth, New Hampshire, in 1853, was bought by the San Francisco owners of the Tacoma Mill Company. She was a familiar sight in Puget Sound waters during the 1880s and 1890s. Converted to a utility barge in 1901, she is shown here in Seattle's Elliott Bay around 1905. (Courtesy PSMHS, No. 4511.)

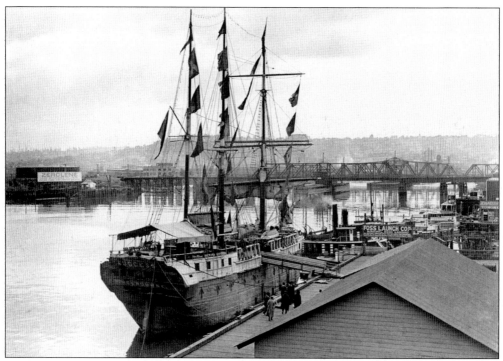

**CONVICT SHIP "CON."** In 1915 and 1916, the *Success*, a widely promoted convict ship that supposedly transported prisoners from Britain to Australia in 1802, toured many Puget Sound ports. Shown here in Tacoma, the ship did serve as a floating jail in 1852, but it was never a prisoner transport ship nor at the time the world's oldest operational vessel, as its owners claimed. (Courtesy Tacoma Public Library, No. G50.1-103.)

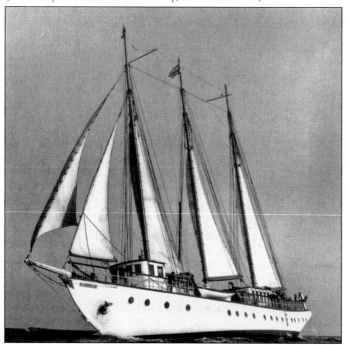

**UNIQUE SAILING YACHT.** Among the many unique sailing vessels either built at or that visited Puget Sound through the years was the unique schooner yacht *San Wan*. Constructed by widely known Seattle shipbuilder Charles Moran, whose yard built the battleship USS *Nebraska*, launched in 1904, the *San Wan* had special luxury accommodations for its owner, family, and guests. (Courtesy WSHS, Curtis No. 36417.)

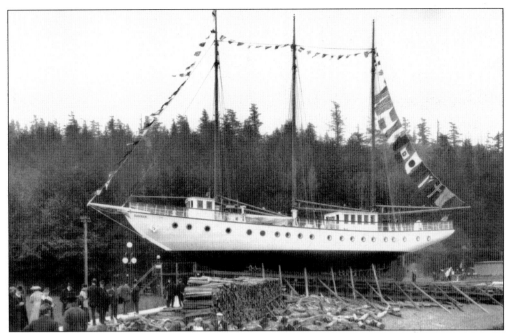

**LEISURE SCHOONER LAUNCHING.** Now a resort, Rosario on Orcas Island was Charles Moran's summer estate. Instead of building his grand schooner yacht at a shipyard in Seattle, it was constructed on the elegant grounds at Rosario. With its unique forward pilothouse, big battleship-like port lights, and festooned with flags, it was readied for launching in 1917. (Courtesy WSHS, Curtis No. 59025.)

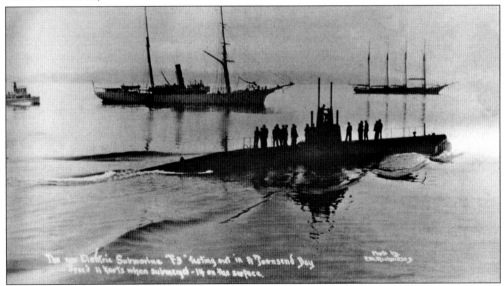

**SAIL-RIGGED SHIPS AND A SUBMARINE.** The rapid progress of marine technical innovation is shown in this 1912 photograph of the U.S. Navy diesel-powered submarine *F-3* leaving Port Townsend on sea trials with a sail-rigged revenue cutter (left) and a four-mast schooner in the background. The submarine was built by the Seattle Construction and Dry Dock Company, the successor to the Moran shipyard. (Courtesy Jefferson County Historical Society, Port Townsend, Washington, No. 2.144.)

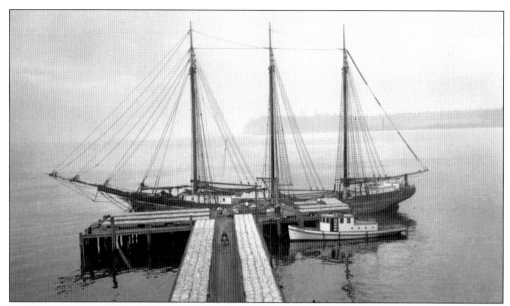

**WAWONA ON THE WATERFRONT.** The schooner *Wawona*, along with the *C. A. Thayer*, *Charles R. Wilson*, *Sophia Christensen*, and others, was among the last of the Puget Sound commercial cod-fishing fleet under sail in the 1940s. The *Wawona* is shown here in 1915 moored at the Robinson Fisheries Company dock in Anacortes as thousands of cod dry on the dock. She has been under restoration for many years as a museum ship in Seattle. (Courtesy UW Libraries, Special Collections, Cobb No. 3829.)

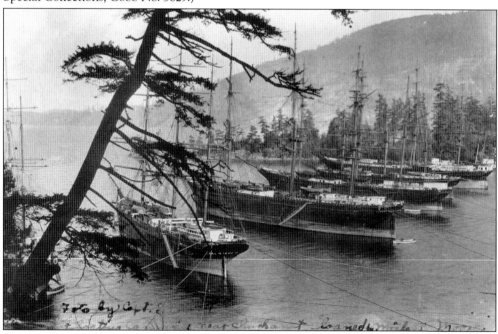

**SQUARE-RIGGER SOLITUDE.** The Pacific Packing and Navigation Company square-rigger fleet is shown here in 1904 during lay up at Pleasant Cove on Chuckanut Bay. The company went bankrupt in 1903, and eight of its canneries were closed. (Courtesy Whatcom Museum of History and Art, Bellingham WA, Image No. X.5416, O.E. Garland Photographer.)

54

**SAIL SHIPBUILDING REBORN.**
During World War I, several
shipyards in Puget Sound built
wooden, sail-rigged auxiliary
schooners for the United States,
France, Norway, and other nations.
Here the five-mast, auxiliary
steam engine–powered schooner
*Gerberviller*, constructed in 1918
by the Foundation Company
on the Hylebos Waterway in
Tacoma, is shown during sea
trials. (Courtesy Tacoma Public
Library, Foundation No. 96.)

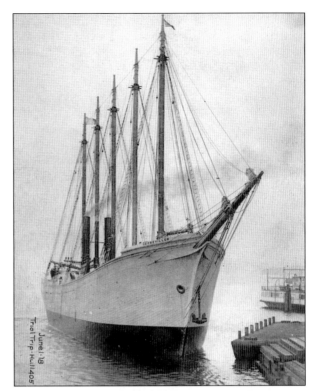

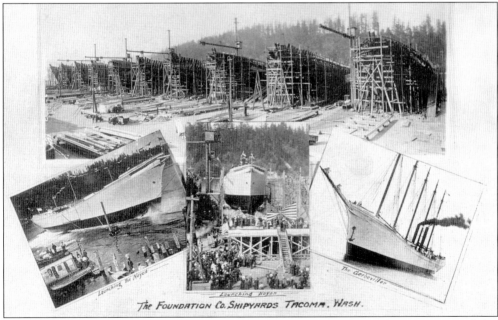

**SCHOONER CONSTRUCTION STAGES.** The Foundation Company shipyard in Tacoma used this
montage postcard to promote its construction of 20 new auxiliary schooners for France. The various
shipbuilding stages are shown, from ships on the ways through launching and sea trials. At the
time, the 50-acre Foundation Company's Tacoma operation was the largest wooden shipyard in
the world. (Courtesy Rob Paterson.)

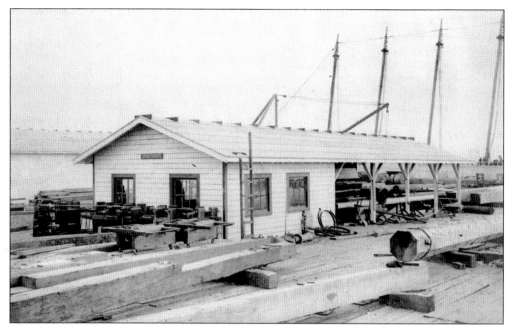

**SHIP SPAR-MAKING SHOP.** Historically sailing ship mast, or spar, making was a craft that required skilled workers. Taken from the shipyard's photograph documentation album, this image shows the Foundation Company's spar house where, both by hand and power lathe, masts and yards were turned out for the awaiting schooners under construction. (Courtesy TPL, Foundation No. 75.)

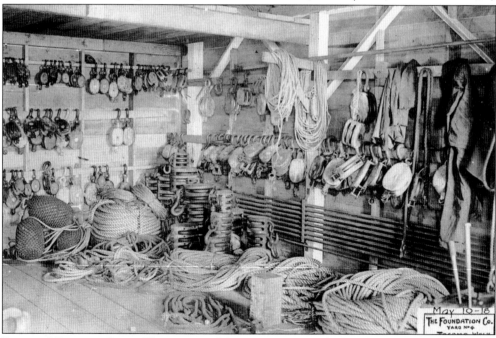

**RIGGERS' STORAGE SHED.** The interior of the riggers' storage shed at the Foundation Company shipyard is filled with various rigging supplies. Wooden blocks, coils of manila line for the standing and running rigging, rope bumpers, and even the riggers' work clothes are seen ready for use. (Courtesy TPL, Foundation No. 37.)

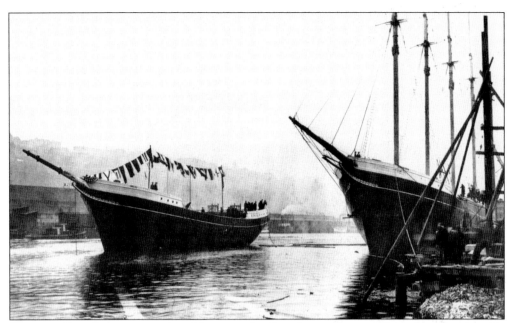

SEABORN SHIP LAUNCHING. In addition to the Foundation Company's yard on the east side of the Tacoma tide flats, the Seaborn Shipyard on the downtown City Waterway also built auxiliary schooners during World War I. Here the black-hulled *Orcas* is launched in 1917, while the *Seaborn*, its spars already *stepped*, or installed, is fitted out at the adjacent dock. (Courtesy WSHS, Seaborn No. 29.)

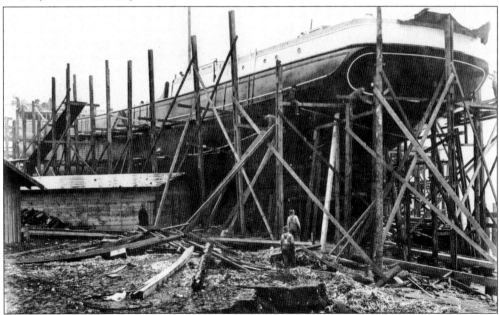

THE WAYS OF A SCHOONER. The massive stern of one of the Seaborn-built schooners under construction on the ways dwarfs the workers at ground level below the transom. The Tacoma shipyard was located on the east side of what is now the Thea Foss Waterway across from two of the surviving historic wheat warehouses, one of which includes the Working Waterfront Maritime Museum. (Courtesy WSHS, Seaborn No. 121.)

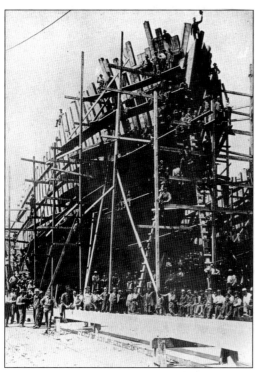

SCHOONER AND SCAFFOLDING. Another shipyard in Puget Sound that built auxiliary schooners during World War I was the Olympia Shipbuilding Company. Posing for a group portrait, one worker at Ward's Shipyard proudly waves a hat from the stemhead or bow timber of a partially constructed ship while others are shown on the scaffolding and ground. (Courtesy Shanna Stevenson and Henderson House Museum.)

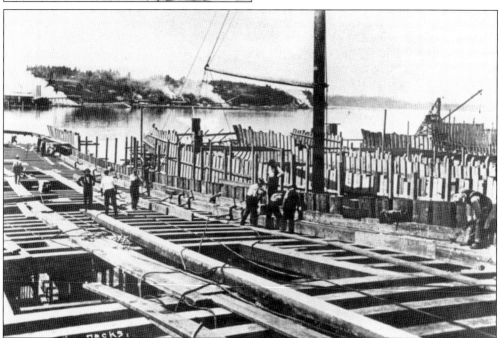

SHIPYARD BY THE BAY. The intricate network of frame and deck timbers is shown in this 1916 photograph of shipwrights building schooners at Ward's Shipyard on Budd Inlet. With the active lumber mills of West Bay visible in the background, the shipyard was located on what is now the Port of Olympia peninsula and marine terminal site. (Courtesy Shanna Stevenson and Henderson House Museum.)

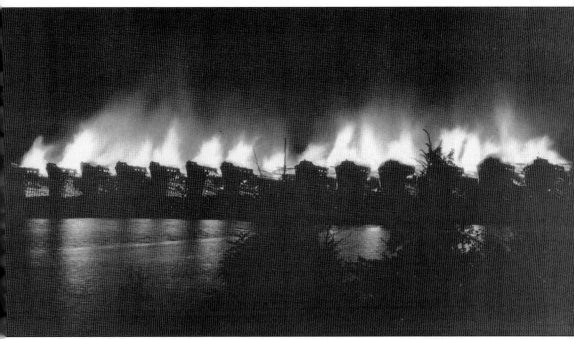

**SCHOONERS' FIERY FATE.** The sad, fiery end for 13 of the auxiliary schooners built by the Foundation Company in Tacoma during World War I is shown in this 1926 photograph taken on the beach at Minter Creek on the Key Peninsula. In all, 46 auxiliary schooners were ordered by the United States and foreign nations from Puget Sound shipyards in Tacoma, Seattle, and Olympia. However, World War I ended before most of them could be delivered, and the contracts were cancelled. The remaining vessels still under construction ended up dismantled, laid up for several years, wrecked at sea or on shore, or in ashes. These schooners meeting a fiery fate were among scores of wooden ships burned for their meager scrap metal value during the 1920s and 1930s. (Courtesy TPL, No. G49.1-007, Chapin Bowen Collection.)

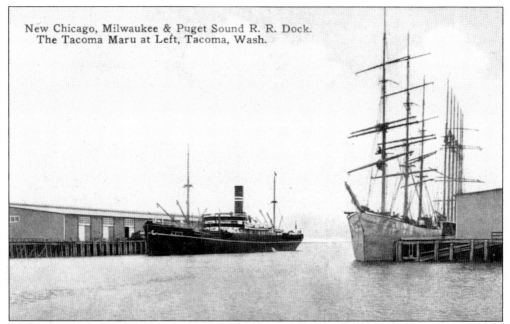

New Chicago, Milwaukee & Puget Sound R. R. Dock.
The Tacoma Maru at Left, Tacoma, Wash.

SAIL TO STEAM TRANSITION. A postcard view shows the Japanese steamship *Tacoma Maru* in about 1909 at the Chicago, Milwaukee, and Puget Sound Railroad Oriental Dock on the Tacoma tide flats. The photograph shows the ongoing marine cargo transition from sailing to steam-powered ships. Reminders of a passing era, a three-mast, square-rigged bark and six-mast barkentine are moored across the waterway from the steamer. (Courtesy Roger and Carolyn Erickson.)

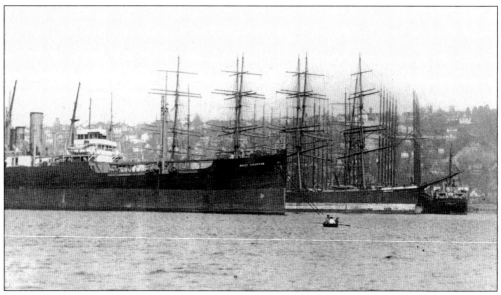

STEAMERS AND TALL SHIPS, SEATTLE. This photograph, taken about 1929 on Lake Union in Seattle, also shows the relentless evolution of marine cargo-carrying technology. Rafted, stored square-riggers are shown in the background with the laid up steamship *West Henshaw* jutting into view from the left and the square-rigger *James Dollar* behind her. One by one, the stored, unused ships left the lake for their final destinations and fates. (Courtesy Mark Freeman.)

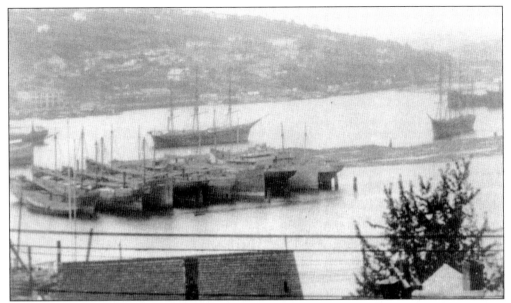

**FLOATING AND FORGOTTEN.** A row of dismasted sailing ship hulls, a lone square-rigger, and log rafts are shown in the late 1920s in this view from the Lake Union hillside. Other once proud vessels were laid up in harbors and bays throughout Puget Sound, rotting and rusting away until the end of their uncertain days. (Courtesy Mark Freeman.)

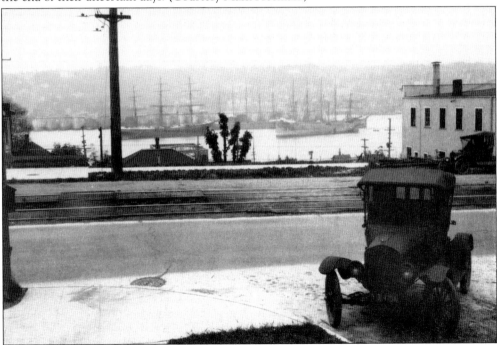

**MODEL T AND TALL SHIPS.** A telephone and electrical power pole and a Ford Model T, two bellwethers of advancing technology, bracket laid up square-riggers in this 1920 photograph taken from Denny Way looking east across Lake Union. However, more than 85 years later, automobiles, trucks, and trains have become the primary people and cargo movers up and down the Pacific coast. (Courtesy UW Libraries, Special Collections, No. SMR 321.)

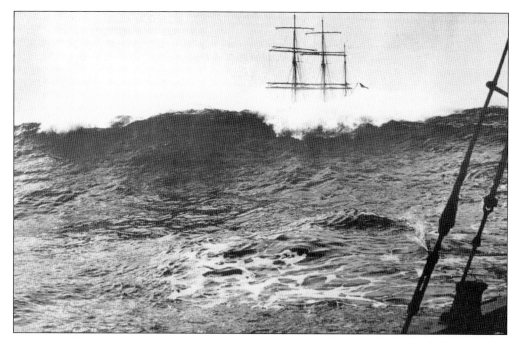

**SPARS AND HIGH SEAS.** Towed by a largely unseen tugboat, a square-rigger—a three-mast bark—is brought through high seas to its safe port in Puget Sound. The rigors of deepwater sailing made men out of boys and leaders out of followers during the hundreds of years that ships have been powered by wind and sails. (Courtesy Rob Paterson, from Williamson Marine Photo Shop.)

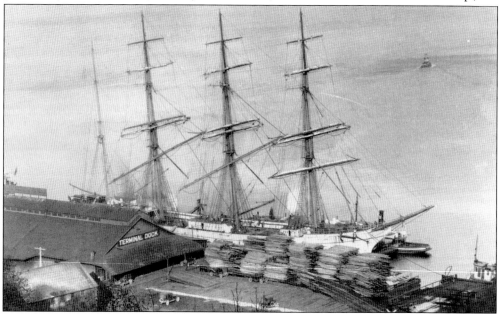

**TALL SHIP IN TACOMA, 1922.** In this photograph, the four-mast bark *William T. Lewis* loads lumber dockside at Tacoma's Terminal Dock on the former City Waterway. This same moorage was used in 2005 by the similar-appearing, square-rigged Mexican national bark *Cuauhtemoc* during its Tall Ships Challenge event visit to Tacoma. (Courtesy TPL, No. B 5218, Marvin D. Boland Collection.)

*Four*

# A SQUARE-RIGGER SAILOR'S STORY
## 1898–1905

Sailing aboard a massive square-rigged ship in the early 1900s was not only a saga of adventure, but also a time of hard, dangerous, seemingly never-ending work. For Willibald Alphons Kunigk, born in Germany in 1880 and who first went to sea in the Baltic in 1898 at the age of 18, it was a life-changing experience. For six years, he was a deepwater sailor on commercial sailing ships, including two voyages around the world. Kunigk rounded Cape Horn in South America and the Cape of Good Hope in Africa several times, ending his sailing days under canvas in 1905 in the Pacific Northwest and on Puget Sound.

As an ordinary seaman, Kunigk did not keep a journal of his onboard experiences during his time at sea; however, he maintained a complete list of each ship on which he sailed and his dates aboard. He was a crewman on six square-riggers, including a voyage from Tacoma to Antwerp, Belgium, in 1901 on the four-masted British bark *Queen Margaret*.

While Kunigk did not chronicle his time aboard this ship, through other contemporary crew member accounts of similar voyages and historical research about the *Queen Margaret*, this square-rigged sailing story can be reconstructed. The addition of some incredible photographs taken by college student Fred Taylor during his own voyage on the *Queen Margaret* ship four years after Kunigk sailed aboard her make this tale even more graphic and dramatic.

Kunigk's personal story both enlivens and enlightens the broader story of the glory days of sail on Puget Sound. It typifies those of thousands of young men who went to sea aboard the great square-riggers and learned hard but valuable lessons that prepared them for successful future lives.

Square-rigged and other sailing ships changed the life of a young German sailor a century ago. And today, at the beginning of the 21st century, similar life-altering experiences still take place on tall ships.

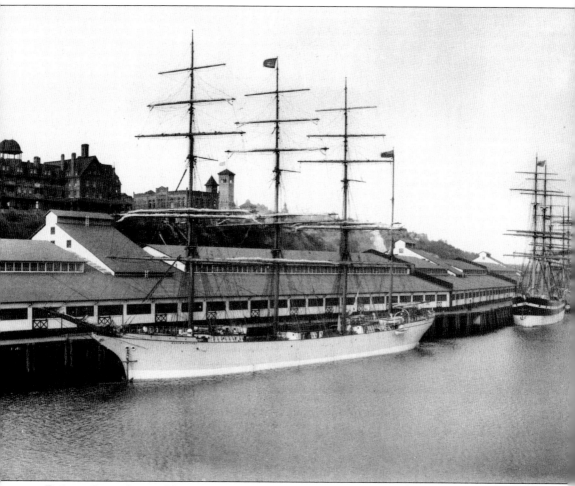

**BRITISH BARK QUEEN MARGARET, 1901.** Built in 1893 in Scotland, the four-mast, 275-foot-long steel bark *Queen Margaret* arrived at Tacoma in December 1900. She berthed at the then new Northwestern Improvement Company warehouse to load a cargo of wheat bound for Belgium. This photograph of the majestic sailing ship was taken by Wilhelm Hester in January 1901 from the first Eleventh Street Bridge over City Waterway. (Courtesy NHP, No. F1.38.038gl, Hester Collection.)

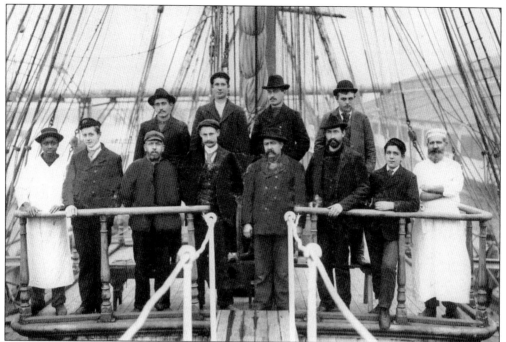

QUEEN MARGARET CREW. Wilhelm Hester photographed the crew of the *Queen Margaret* in Tacoma in 1901. Once fully loaded with grain, the ship of more than 2,000 tons gross cargo-carrying capacity departed for its 100-day voyage around Cape Horn in South America to Antwerp, Belgium. Among its crew members was a 21-year-old German sailor, Willibald Alphons (W. A.) Kunigk, who later became a U.S. citizen and prominent Tacoma resident (second row, second from right in hat). (Courtesy Bill Kunigk.)

HIGH SEAS SHIP PAINTING. A Hester photograph of a painting in the captain's cabin of the *Queen Margaret* shows the bark under shortened sail battling heavy seas during a long distance, full-cargo voyage. This treacherous wind and sea condition was commonly known as a "Cape Horn Snorter" by the captains and crews of ships rounding the southern tip of South America. (Courtesy Bill Kunigk.)

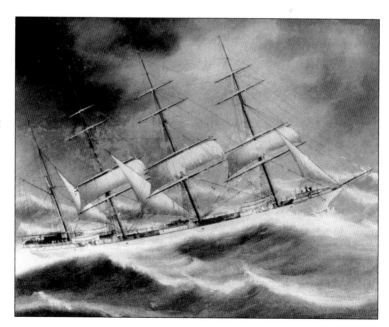

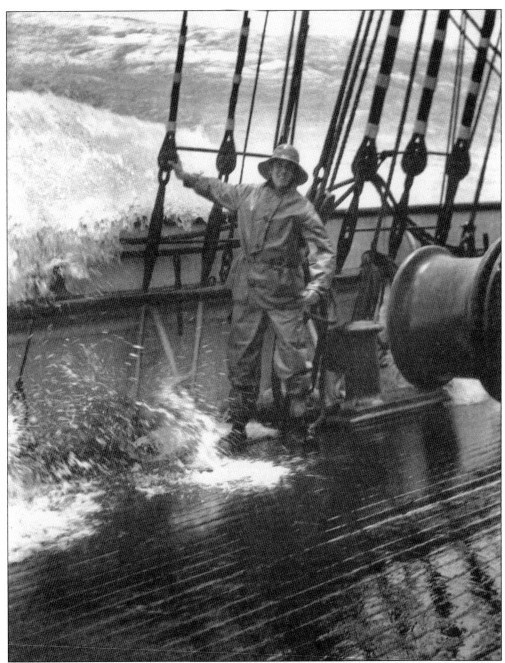

**QUEEN MARGARET VOYAGE, 1905.** Four years after 21-year-old W. A. Kunigk sailed around Cape Horn aboard the *Queen Margaret* as a deckhand, 19-year-old college student Fred Taylor took a similar voyage from New York around the Cape of Good Hope in Africa to Freemantle, Australia. A "working" passenger, Taylor documented his journey using an early Kodak box camera and roll film. He is shown here in his oilskin stormwear hanging onto a shroud with decks awash. (Courtesy Tad Lhamon.)

**MIZZENMAST MOMENT.** At the beginning of his square-rigger voyage, Fred Taylor was photographed in the ship's rigging on the mizzenmast crosstree. Part of the bark's set of sails is shown at right, and when all the canvas was raised, or "bent on," she carried about 30,000 square feet of sail. (Courtesy Tad Lhamon.)

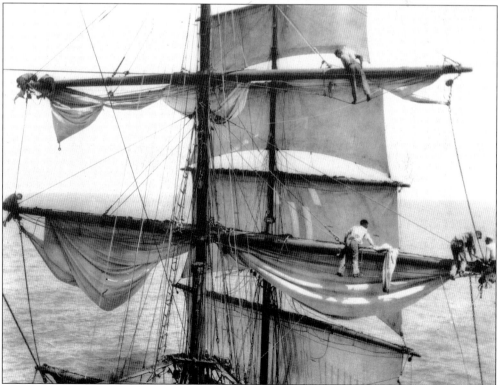

**CREW CHANGES SAILS.** According to Fred Taylor's 1971 recollection of his *Queen Margaret* voyage, this photograph shows crew members taking the old patched sails off the yards before putting on new ones. This was usual practice before the often dangerous voyage track around the Horn to help prevent the sails from being blown out by the strong westerly winds. (Courtesy Tad Lhamon.)

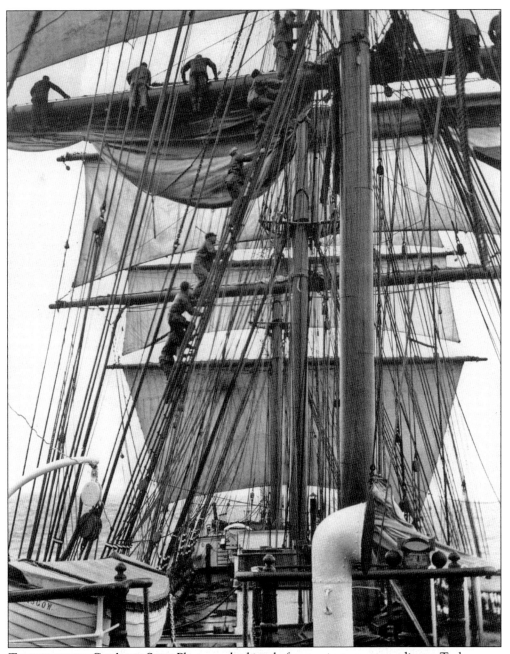

**TAKING IN THE CRO'JACK SAIL.** Photographed just before a rainstorm, according to Taylor, crew members climb the weather shrouds and take in the ship's cro'jack, or crossjack sail, which is the main course on the mizzenmast or farthest aft mast. Taylor recalled that this sail was about 90 feet across, 35 feet high, and would take about 15 sailors to furl. (Courtesy Tad Lhamon.)

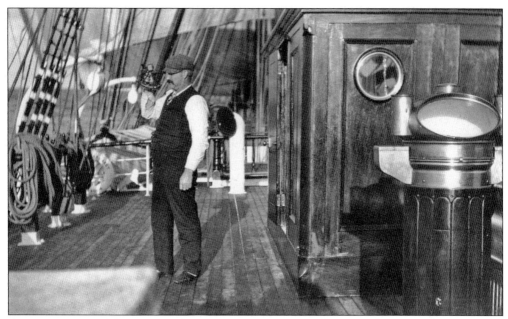

**CAPTAIN TAKING NAVIGATION SIGHTING.** During an oral history of his voyage on the *Queen Margaret* recorded when he was 85-years-old, Taylor mentioned that the ship's master, Captain Scott, was an experienced seaman. Shown here on the poop deck taking a sextant sighting, Scott had crossed the Atlantic Ocean 98 times as a captain and about 200 times as a sailor. "He was a very high grade citizen," Taylor said. "He knew his business." (Courtesy Tad Lhamon.)

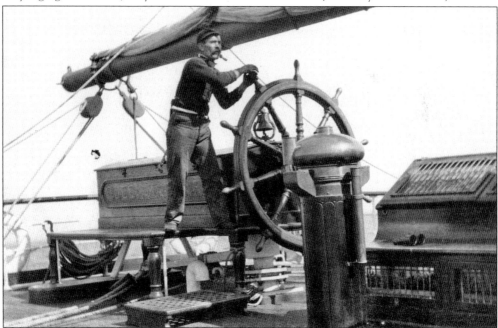

**BOATSWAIN AT THE WHEEL.** Although normally the boatswain was not supposed to steer the ship himself but supervised other crewmen who did, Fred Taylor convinced him to do so for this photograph. Later in the voyage, when he gained experience and the confidence of the officers and crew, the teenaged Taylor was allowed to steer the *Queen Margaret* himself. (Courtesy Tad Lhamon.)

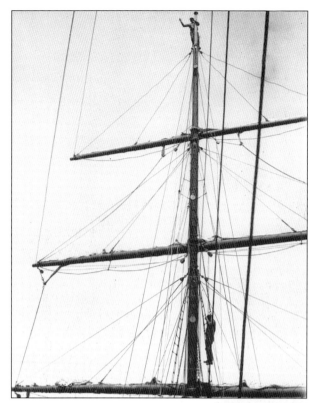

**Top of Main Mast Wave.** An intrepid, fast-learning college student who wanted to experience square-rigger sailing before the end of the age of sail, Fred Taylor was photographed waving from atop the main mast. This and the top of the other square-rigged masts is the highest point on the ship, about 165 feet from the main deck. (Courtesy Tad Lhamon.)

**Ship Rolling, Deck Awash.** Taylor took this photograph of the *Queen Margaret* heeling to port during what he called a "big blow." He remembered that at the time the ship was plowing through 12 to 15 foot high seas in the South Atlantic in the "roaring 40's" latitudes. (Courtesy Tad Lhamon.)

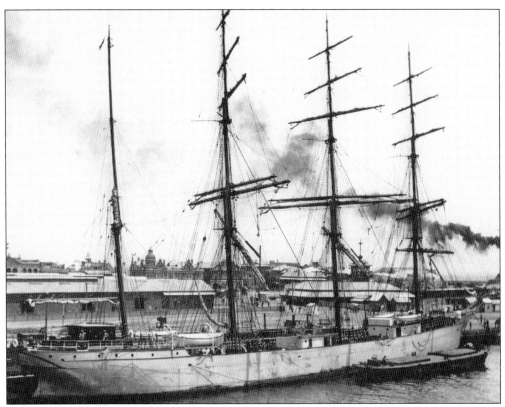

**END OF VOYAGE IN AUSTRALIA.** After a 101-day voyage from New York City, the *Queen Margaret*, arrived in Freemantle, Australia, to unload its cargo. In an interview when he was in his 80s, Fred Taylor summed up his epic square-rigger sailing experience. He said it was the "regret of his life" that, because he had to return to college, he had to leave the ship in Australia and not continue on its around the world voyage. (Courtesy Tad Lhamon.)

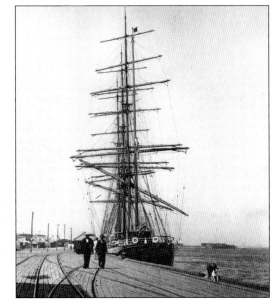

**FINAL FAREWELL.** This final photograph taken by Fred Taylor shows a stern view of the *Queen Margaret* laying alongside the wharf in Australia. Discussing this scene later in his life, Taylor recalled nostalgically that this was "my last view of a beautiful bark." (Courtesy Tad Lhamon.)

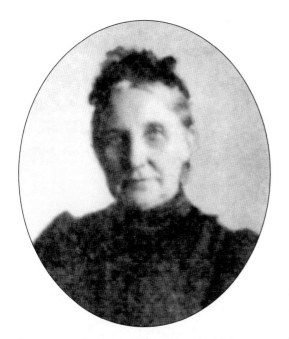
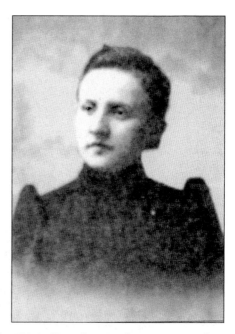

SAVIORS OF SAILORS. When 21-year-old German sailor W. A. Kunigk arrived in Tacoma in late 1900 and early 1901, before signing aboard the *Queen Margaret*, he made the first of many visits to the Seamen's Rest mission in Old Town. Both a boardinghouse and religious outreach mission, it was operated by a Norwegian immigrant widow, Brigitte Funnemark (left), and her daughter Christine. (Both courtesy Ron Burke and Elizabeth Eugle, PSMHS.)

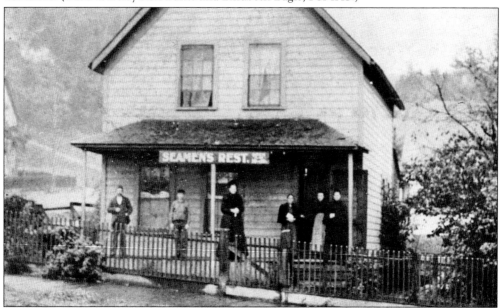

HOME AWAY FROM HOME. Between ship crew assignments, transient sailors visiting Tacoma and other Puget Sound ports could go to either downtown saloons and houses of ill repute, or religious or other boardinghouses. W. A. Kunigk found a home away from home at Seamen's Rest, and his early and later friendship with the proprietors, the Funnemarks, later became a major influence in his life. (Courtesy Ron Karabaich, Old Town Photo.)

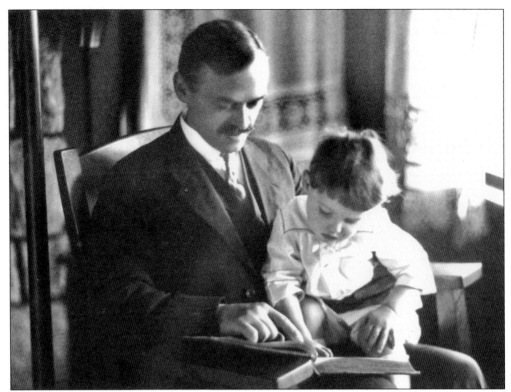

**FROM SAILOR TO FAMILY MAN.** After deciding to emigrate to the United States at the end of his days at sea, W. A. Kunigk studied to become an engineer, married, and began pursuing his career and raising a family. Here, in about 1919, he reads to his young son Bill at the family home. (Courtesy Bill Kunigk.)

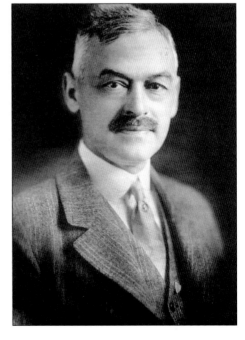

**CIVIL ENGINEER, CIVIC LEADER.** Shown in a 1926 portrait taken when he was 46 years old and superintendent of the Tacoma City Water Department, German immigrant and square-rigger sailor W. A. Kunigk had, by 1917, risen from a draftsman in 1911 to become the organization's top engineer, and also a civic leader. (Courtesy Bill Kunigk.)

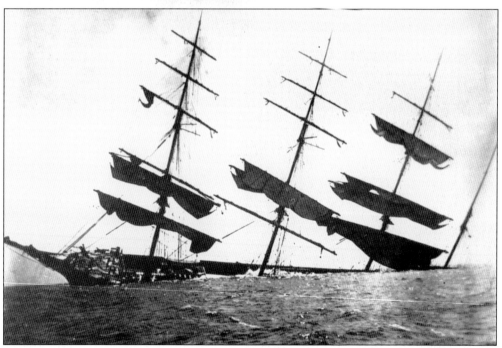

**QUEEN MARGARET UNDER SAIL.** Among the few photographs of the *Queen Margaret* under full sail is this hazy but still impressive historical image. In a 1928 magazine article, a well-known maritime author and former square-rigger sailor called the British sailing vessel one of the "most beautiful four-mast barks ever built." (Courtesy John Oxley Library, State Library of Queensland, Australia.)

**WRECKED, COAST OF ENGLAND.** After 20 years sailing the oceans of the world, the *Queen Margaret* was wrecked in 1913 on Stag Rocks near Lizard Point in Cornwall, England. After a long voyage, the captain or master brought the bark too close to the shore to receive its owner's port arrival instructions. The crew abandoned the ship successfully, but its valuable cargo was a total loss. (Courtesy John Oxley Library, State Library of Queensland, Australia.)

**OLD SAILOR, VIVID MEMORIES.**
Interviewed by a newspaper reporter
in 1974 when he was 93, W. A. Kunigk
recalled that as a young sailor he was "small
and agile" and always the crewman who
climbed highest up the main mast. "I could
work the sails in the worst storms," he said,
"and it never bothered me." (Courtesy the
*News Tribune*, Tacoma, photographs by
Warren Anderson, 1974 file photographs.)

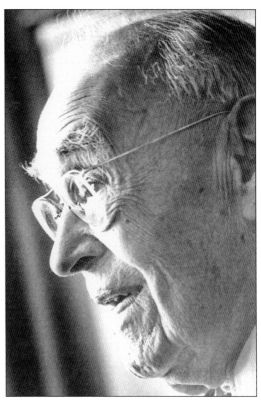

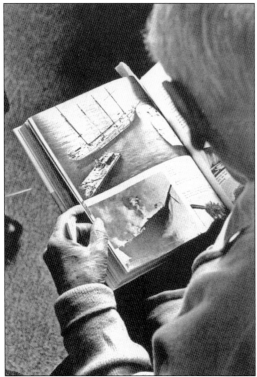

**SAILING DAYS SAD END.** Among the
many ships on which W. A. Kunigk
sailed was the three-mast, 223-foot-long
full-rigged ship *Abner Coburn* built in
Maine in 1882. Here in a newspaper story
photograph, he views a picture of the
*Coburn* at the end of its seagoing days in
the 1920s being burned on a beach near
Seattle for its scrap metal salvage value.
(Courtesy the *News Tribune*, Tacoma.)

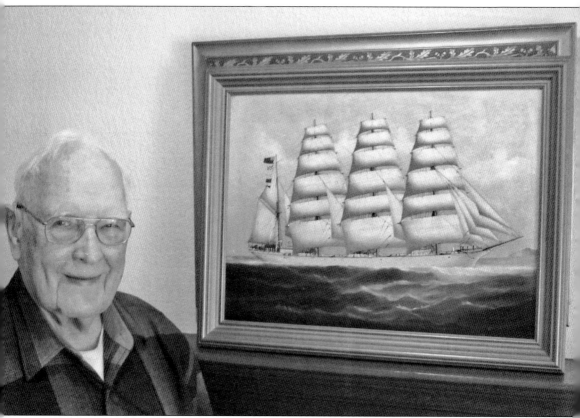

**Ship Painting, Family Legacy.** Bill Kunigk, son of W. A. Kunigk, is shown with his father's treasured painting of the *Queen Margaret*. Bill, a successful businessman, World War II veteran, and a lifelong sailor and boater, served for many years as a U.S. Coast Guard Auxiliary officer in Tacoma. (Courtesy Chuck Fowler.)

*Five*

# END OF A PROUD ERA
## 1930–1950

Writing in *The H. W. McCurdy Maritime History of the Pacific Northwest, 1895–1965*, maritime historian Gordon Newell summed up the end of a proud sailing era. He said, "Of all of the ships which took part in the 1927–1928 revival of sail, only one—the *Moshulu*—was destined to sail offshore again from the [Pacific Northwest] region 'under canvas.'"

Nostalgically, Newell observed that "the major economic depression of 1929 in the United States and worldwide dashed the hopes of sailing cargo-ship owners for their economic salvation, and the careers of many of the old windjammers." He went on to note: "The downward trend continued in 1932 . . . The history of the period . . . until the outbreak of the Second World War is more a chronology of curtailed services, abandoned routes, bankrupt shipping enterprises and scrapped vessels than of progress and development."

A few surviving square-riggers found occasional low priority bulk product cargos and roles in pirate-themed and other motion pictures until the early 1940s and the beginning of World War II; however, the last days of the commercial tall sailing ship sail were truly over.

In Puget Sound, the old, out-of-work sailing ships were laid up at several locations, including Lake Union in Seattle and Eagle Harbor on Bainbridge Island. The last of the square-riggers with commercial cargos that departed from Washington State took their final voyages just before and after the beginning of World War II.

As Robert Carse wrote in his book *The Twilight of Sailing Ships*, "The owners of commercial ships were finished with sail as a means of motive power. Vessels that had been rigged in essentially the same way for over 450 years, and which had been used by all the great circumnavigators of history, were about to go out of existence forever."

While sad to witness, the end of the once proud windjammers and their conversions to towed barges or even burned for their scrap metal value, set the stage for a return of these sailing ships in new historical and educational roles. While this period of decline and disappearance must be chronicled and documented, out of this seemingly conclusive end came a new beginning.

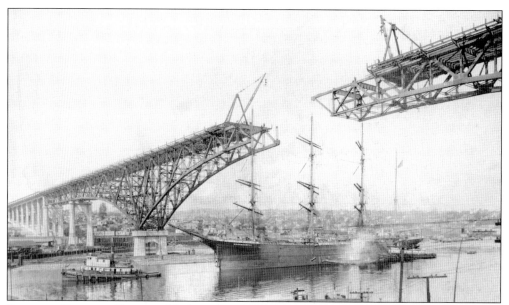

**BRIDGING PAST AND FUTURE.** Marking the passage from one tall ship era to another, in late 1931, the four-mast bark *Monongahela* was towed through the closing gap in the George Washington Memorial Bridge, commonly known as the Aurora Bridge, in Seattle. The ship was among several big square-riggers laid up and stored in Lake Union during the 1920s, all of which had to leave before bridge construction was complete because their masts were too tall. (Courtesy PSMHS, No. 5902.)

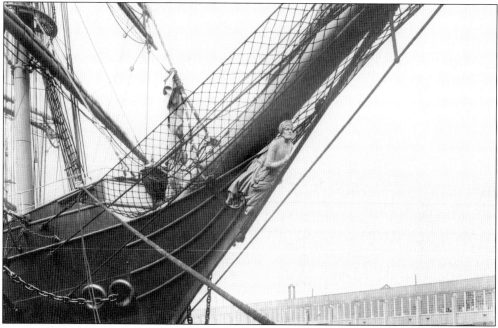

**FANCY FIGUREHEAD.** The figurehead of the *Monongahela*, originally named *Balasore*, was a representation of the prince of Balasore, a city in southeastern India on the Bay of Bengal. This proud ship was converted to a log barge in 1936 and operated in British Columbia where it ended its days in the early 1940s. (Courtesy PSMHS, No. 5648.)

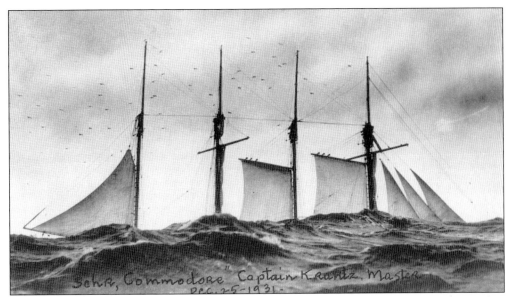

SEA-TOPPED TOPMASTS. Only the tops of the masts and sails of the four-mast schooner *Commodore* are seen above the cresting waves in this dramatic 1931 photograph. The *Commodore* and the five-mast schooner *Vigilant* participated in a series of so-called races as they each carried cargos between Hawaii and Puget Sound. (Courtesy PSMHS No. 650-2.)

COMMODORE AT BELLINGHAM. The *Commodore*, shown here in 1923 loading lumber in Bellingham, was still sailing in the 1930s, carrying lumber and other cargos from Puget Sound to Hawaii and also Alaska. According to maritime historian Gordon Newell, the *Commodore* and the *Vigilant* were the last of the offshore sailing fleet still in service on Puget Sound. (Courtesy Whatcom Museum of History and Art, No. 2004.17.6, Fred Jukes Photographer.)

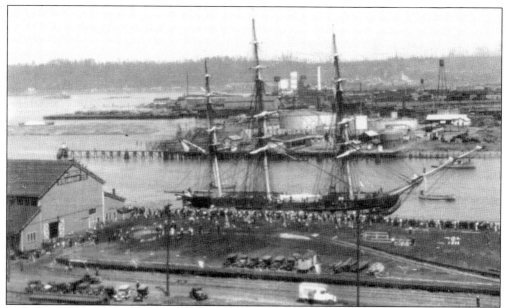

CROWDS VISIT CONSTITUTION. In 1933, as part of a three-year, 22,000-mile national tour, the historic U.S. Navy frigate USS *Constitution* visited the Pacific coast, including many Puget Sound port cities. It is shown here at the McCormick Terminal dock in Tacoma, the same moorage site used more than 70 years later by the square-rigged Mexican and Russian national ships that visited during the Tall Ships Challenge event in 2005. (Courtesy Tacoma Public Library, No. 639-1, Richards Studio Collection.)

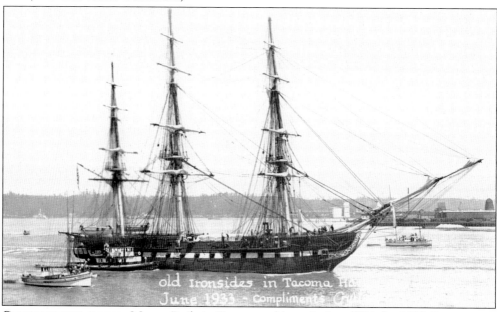

CONSTITUTION ON THE MOVE. Built in Boston and launched in 1787, the USS *Constitution*, because of its age and heavy 1933 port visit schedule, was towed rather than sailed from city to city for exhibit. Here a Foss tugboat guides the ship to its moorage berth on Tacoma's City Waterway. More than 84,000 visitors toured the historic vessel during its weeklong stay. (Courtesy Rob Paterson.)

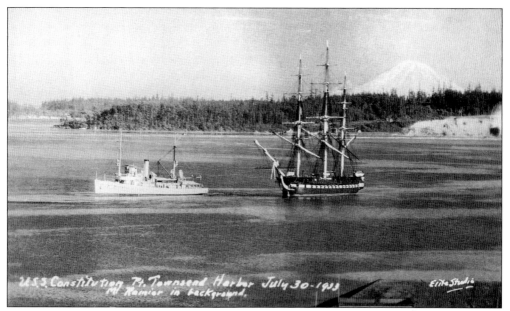

**HISTORIC FRIGATE AND MOUNT RAINIER.** At the end of its 1933 summer tour of Puget Sound ports, the USS *Constitution* was photographed at Port Townsend on its way to the Pacific Ocean and its eventual return to its Atlantic home port, Boston. For most of its time in the sound, as well as offshore, it was towed from city to city by the converted navy minesweeper USS *Grebe*. (Courtesy Jefferson County Historical Society, Port Townsend, Washington, No. 2.60.)

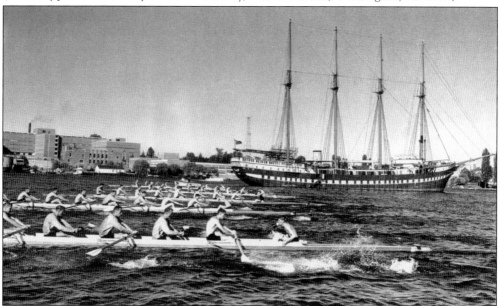

**SCHOONER YACHT IN SEATTLE.** Among the many interesting tall sailing ships to visit Puget Sound through the decades was the four-mast schooner yacht *Fantome*. Shown here anchored in Portage Bay behind passing University of Washington rowing crews, the vessel was owned by British brewing magnate A. E. Guinness. It remained in Seattle throughout World War II and was a familiar local sight until leaving the sound in 1953. (Courtesy MOHAI, Scaylea No. 1993.20.298.)

**SILENT SHIP AND SNOWFALL.** In an artful 1927 photograph titled "Winter Refuge" of a once-proud tall ship turned fish tender, Seattle physician and photographer Kyo Koike recorded the latter day demise of the region's sailing ships. An American citizen of Japanese descent, Koike pursued poetry, literary, and artistic interests, in addition to his medical practice, and developed a creative, soft-focus photographic style reminiscent of Oriental artistic traditions. (Courtesy UW Libraries, Special Collections, Koike No. 26959z.)

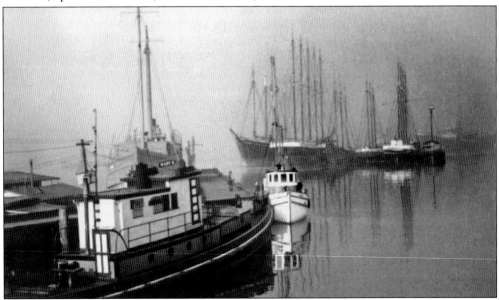

**FOG SEASON SHIPS.** In an image he called "Lake Ghosts," Kyo Koike captured the loneliness of fog-bound tall ships in lay up on Lake Union during the late 1920s and 1930s. Unfortunately, Koike's medical profession and photographic interests were interrupted by his internment, along with thousands of other Japanese American citizens, in one of the many relocation camps during World War II. Although he returned to Seattle in 1945, Koike never returned to his passion for photography. (Courtesy UW Libraries, Special Collections, Koike No. 26960z.)

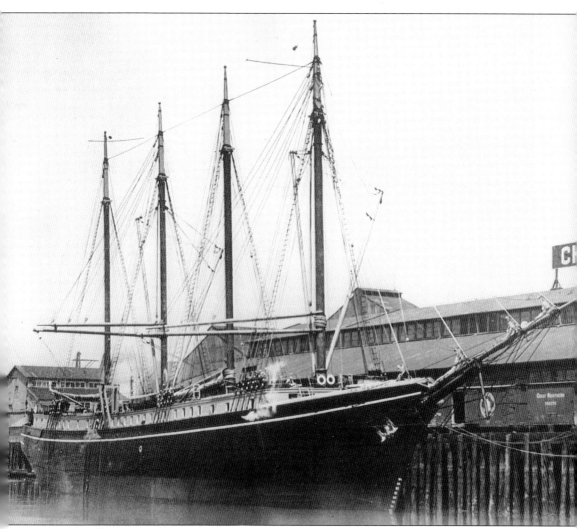

**STATELY SCHOONER.** The 232-foot-long, auxiliary motor–powered schooner *La Merced*, shown here at an unknown Puget Sound waterfront location, was built in Benicia, California, in 1917. One of many new, wooden auxiliary engine–powered schooners built during World War I, it was used for almost 10 years in the Pacific coastal and offshore petroleum transport trade. (Courtesy Ron Burke, PSMHS.)

**TALL SHIP BREAKWATER.** In 1966, after many years as a floating cannery in Alaska and in lay-up storage, the *La Merced* was sold to Tony Lovric of Anacortes as a breakwater for his marina and ship maintenance operation located west of the city. It is seen here beached at the beginning of marina construction. (Courtesy Ron Burke, PSMHS.)

**BEACHED BULK CARGO SCHOONER.** A later view of the hull of the former *La Merced* from the beach shows its massive size. Once proudly sailing the waters of the Pacific, Alaska, and Puget Sound, as a breakwater, the schooner was filled with dredge spoils that soon supported a thriving grove of shipboard trees and bushes. (Courtesy Ron Burke, PSMHS.)

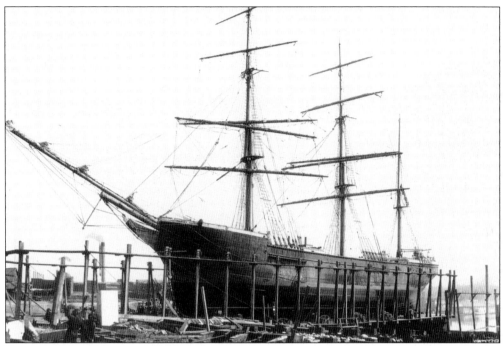

**DIAMOND HEAD HAULED.** Hauled out at a shipyard marine railway in Ballard about 1910, the graceful lines of the four-mast bark *Diamond Head* are readily apparent. Formerly the *Gainsborough*, the square-rigger was built in London in 1866, bought by a Hawaiian company in 1898, and renamed for the Honolulu landmark. The majestic iron tall ship was converted to a barge in 1910 for use in Alaska before its later service in Puget Sound. (Courtesy PSMHS, No. 4393-6.)

**DIAMOND HEAD IN THE ROUGH.** Without masts, cut down and converted for use as an oil storage barge, the former square-rigger *Diamond Head* is shown in 1949 at the dock in front of the Seattle Steam Plant on the east side of Lake Union. The subject of many fictional, inaccurate stories, it was described as the first iron sailing ship in the world, a former pirate vessel, and in other identities—none of which were true. (Courtesy PSMHS.)

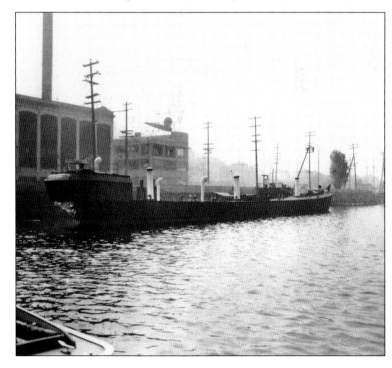

**FINAL FATE.** The *Diamond Head* is towed by a small tugboat into Puget Sound on its final fate voyage in 1950. This view from the bow of the once proud sailing ship shows the striking up-turned stem, which cradled a long, forward-pointing bowsprit. (Courtesy PSMHS, No. 4393-24.)

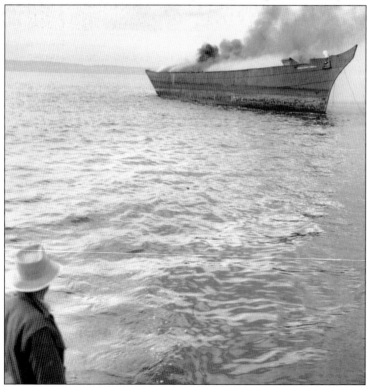

**IRON SHIP BURNING.** Cut loose from its tow and set afire, a tugboat crewman watches the sad end of the former *Diamond Head* as its wooden decks and other flammable parts burn. Once gutted, the hulk was towed back to a Seattle shipyard to be cut up for its remaining scrap metal value. (Courtesy PSMHS, No. 4393-10.)

**A SCHOONER SAVED.** In early 1950, the three-mast, 219-sparred-length wooden schooner C. A. *Thayer* was saved from an ignominious end. Built in 1895 by the Hans Bendixsen shipyard in northern California, it had a long working career as a lumber schooner on the Pacific coast and later operated out of Puget Sound as a salmon and then cod-fishing sailing vessel in Alaska. (Courtesy Chuck Fowler.)

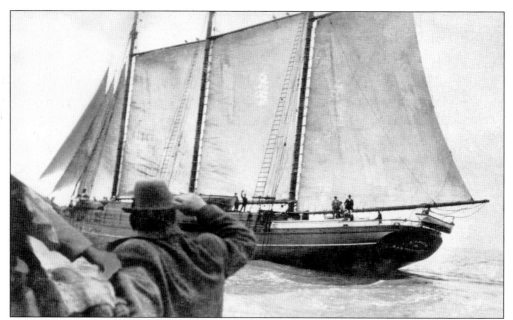

**THAYER UNDER SAIL.** Purchased from the E. K. Wood Lumber Company by Capt. Peter Nelson of San Francisco in 1912, the *C. A. Thayer* began more than a decade of annual voyages to Alaska as part of the salmon fishery. The schooner is shown here under sail in April 1912 on its way to Bristol Bay. (Courtesy San Francisco Maritime National Historical Park, No. J7.5,134n.)

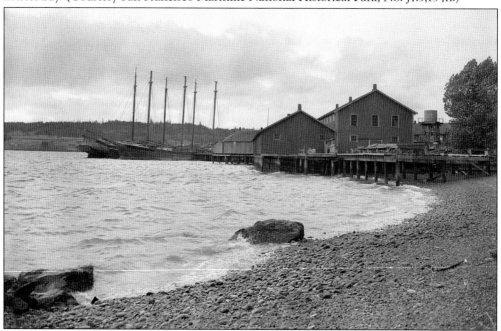

**SCHOONERS OFF-SEASON.** The schooners *C. A. Thayer*, *Sophia Christenson*, and *Charles R. Wilson* are shown at the Pacific Coast Codfishing Company dock in Poulsbo in 1946. The last cod-fishing voyage from Puget Sound under sail to Alaska took place in 1950, and this ended the era of economically viable use of sailing schooners within the region. (Courtesy San Francisco Maritime National Historical Park, No. F11.2,617n.)

**SILENT SCHOONERS.** With the end of the commercial-sailing schooner era in Puget Sound, the *Charles R. Wilson* (left) and *C. A. Thayer* were laid up in Puget Sound to await an uncertain future. The *C. A. Thayer*, as shown here, was deteriorating rapidly, but an entire new role as a historic exhibit sailing ship was on the horizon in its home state of California. (Courtesy San Francisco Maritime National Historical Park, No. P80-006a.6n; photograph by J. A. Gibbs Jr.)

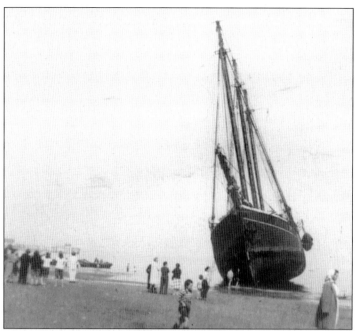

**BEACHED AND BOTTOMED OUT.** Following its retirement from active commercial cod fishing, the schooner C. A. *Thayer* was careened, or beached, at Hood Canal for bottom cleaning and painting as it had so often during its working career. This scene was repeated in 1957 before its departure from Puget Sound after the State of California bought the *Thayer* as part of a new collection of historic vessels for public exhibit on the San Francisco waterfront. (Courtesy PSMHS, No. 118-5.)

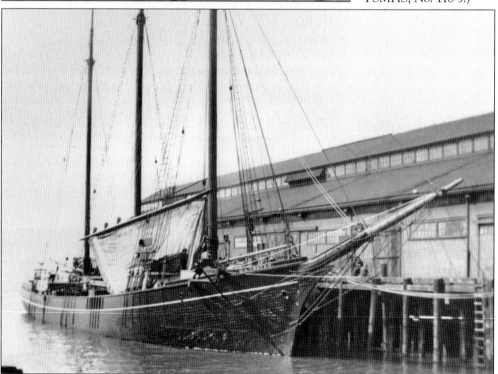

**FINAL VOYAGE PREPARATIONS.** After several months of refitting at Winslow on Bainbridge Island, the schooner was provisioned in Seattle and made ready for its more than 1,000-mile voyage under sail down the coast to San Francisco in 1957. This would be the last major coastwise trip by a historic commercial schooner, one that had served on the Pacific coast and in Alaska for more than a half century. (Courtesy PSMHS, No. 118-35.)

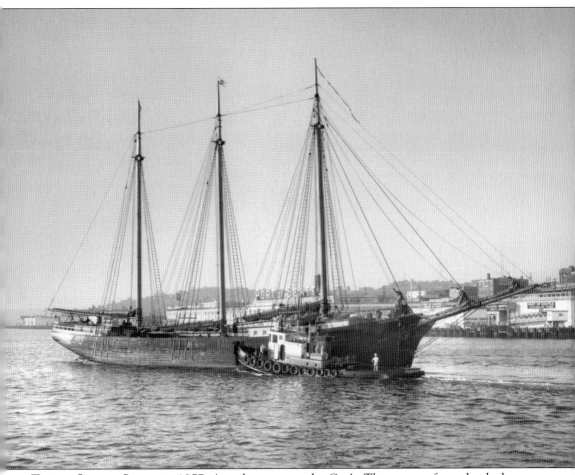

**THAYER LEAVES SEATTLE, 1957.** A tugboat moves the C. A. *Thayer* away from the dock on the Seattle waterfront and past a Port of Seattle warehouse on its way out of Puget Sound to San Francisco. The last two of the former Robinson Fisheries Company fishing schooners were destined to be museum ships, the C. A. *Thayer* in San Francisco and the *Wawona* in Seattle. (Courtesy PSMHS, No. 118-20.)

**CREW MEMBER COLLEAGUES.** Adrian "Cap" Raynaud (left) and Capt. Harold Huycke, both experienced shipmasters, were among the 16-man crew that in 1957 sailed the C. A. *Thayer* to its new maritime museum destination in San Francisco. Cap, a veteran square-rigger sailor, sailmaker, and later ship surveyor, was the schooner's captain during its last major sailing voyage, and Huycke was the boatswain. (Courtesy San Francisco Maritime National Historical Park, No. F9.38,808n.)

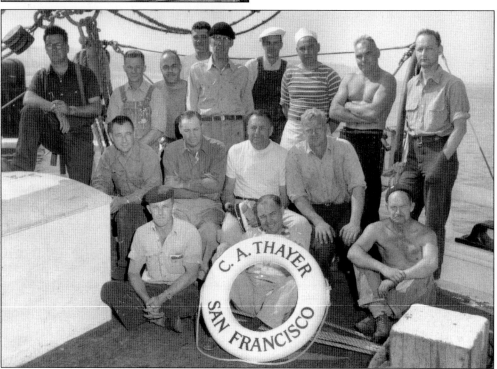

**THAYER VOYAGE CREW.** Among those on the crew for the C. A. *Thayer's* final voyage from Puget Sound to San Francisco Bay was Karl Kortum (back row, far left), the director of the San Francisco Maritime Museum, who spearheaded the idea to preserve and exhibit a collection of significant West Coast historical ships. Also shown are Cap Raynaud (second row, white T-shirt) and Capt. Harold Huycke (front row, left). (Courtesy PSMHS, No. 118-10, Capt. Harold Huycke.)

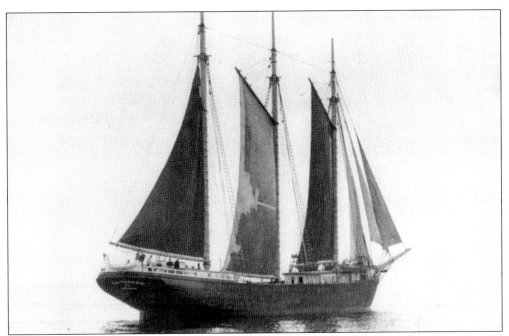

**PUGET SOUND FAREWELL.** The C. A. *Thayer* is shown leaving Puget Sound under sail as she makes her way north to the Strait of Juan de Fuca and Cape Flattery before turning south toward California. Each crew member volunteered for the historic, once-in-a-lifetime sailing opportunity. (Courtesy PSMHS, No. 118-32.)

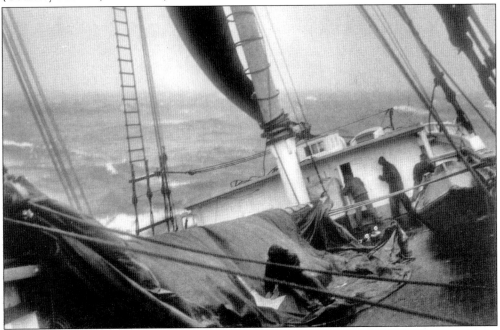

**ROUGH SEAS EN ROUTE.** The longtime Puget Sound working schooner C. A. *Thayer* is shown back in a familiar environment on her way down the Pacific coast, heeled over in a gale and rough seas off Point Cabrillo near Mendocino, California. The sailing vessel's last voyage to San Francisco took about two weeks. (Courtesy PSMHS, No. 118-34, Capt. Harold Huycke.)

93

**SAN FRANCISCO MUSEUM SHIPS.** The C. A. *Thayer* (foreground) and the steam schooner *Wamapa*, built in 1915 and later named *Tongass*, are shown at Hyde Street Pier as part of the historic ships collection at the San Francisco Maritime National Historical Park. Both the *Thayer* and the *Wamapa* had working histories in Puget Sound, Alaska, and elsewhere in the Pacific Northwest. (Courtesy PSMHS.)

# Six

# THE TALL SHIPS RETURN
## 1951–2005

Beginning in 1950 with the end of the sailing schooner fishery in Alaska, some of its well-known Puget Sound–based vessels became the icons of the region's maritime history, as well as that of the Pacific coast.

Led by enthusiastic maritime historians and preservationists, the former Robinson Fisheries Company schooner C. A. *Thayer* was purchased in 1957 by the State of California to be restored as a floating exhibit in San Francisco. Another of the company's former schooners, the *Wawona*, was saved by a similar group in Seattle and remains scheduled for restoration and exhibit.

During the past half century, several other schooners were also saved, restored to active sailing roles, and remain operating on Puget Sound as floating educational classrooms.

Among the ship preservation stewards and educational visionaries who led these efforts was Ernestine "Erni" Bennett, or "Mrs. B" as she was admiringly known by many. A mother, Girl Scout leader, sailing enthusiast, and maritime history advocate, she, along with Aubrey W. "Monty" Morton and Capt. Karl Mehrer, was the savior and longtime protector of the striking, 136-foot-long schooner *Adventuress*. Erni became a quietly powerful educational force, and with her crew of dedicated volunteers, she led the expansion of the youth sail training movement in the Pacific Northwest and Puget Sound.

In addition to these educational lasting legacy efforts, many tall sailing ships have visited Puget Sound during the past half-century. Whether to help commemorate Washington State's Centennial in 1989, during the American Sail Training Association's Tall Ships Challenge events of 2002 and 2005, or individually, these majestic sailing ships made many port calls in the sound. Led by the visits of America's tall ship, the U.S. Coast Guard four-mast bark *Eagle* in 1965 and 1978, these square-rigged vessels have represented Japan, Mexico, Russia, Ecuador, Chile, and other nations. In addition, the two-mast brig *Lady Washington* has been among the many smaller tall ships to participate in events and offer educational programs throughout the sound. Built in 1787 for the Washington Centennial, she is a representation of one of the first two American sailing vessels to explore what is now Washington State. In 2007, the state legislature passed a bill that was subsequently signed into law naming the *Lady Washington* the state's official ship.

The past 50 years has been a period of resurrection and renewal for the region's tall sailing ship heritage and a strong foundation for its future growth and development.

**"Doc" Saves Adventuress.** Legendary Seattle boat broker O. H. "Doc" Freeman saved the well-known Pacific Northwest schooner *Adventuress* when he bought the retired San Francisco sailing vessel in 1952. With a crew of five, Freeman sailed the former pilot schooner up the coast to Seattle. It is shown here with its working bald-headed rig and dark paint scheme in the Lake Washington Ship Canal after its arrival. (Courtesy PSMHS, No. 5035.)

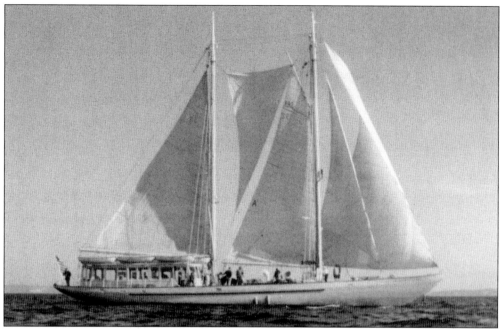

**"School Bus" Pilothouse.** Seattle real estate developer and Sea Scout leader Aubrey W. "Monty" Morton bought the *Adventuress* in 1959 and installed a larger, more comfortable, but non-nautical-looking pilothouse named informally the "School Bus." Under Morton's ownership, the schooner served as a Sea Scout training vessel for the next 15 years. (Courtesy Sound Experience.)

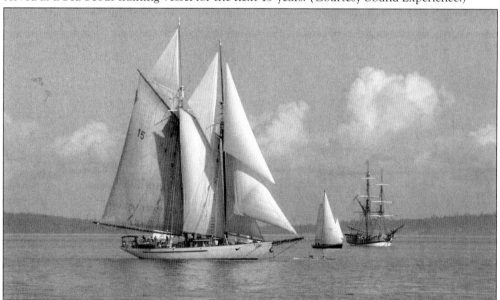

**Adventuress Meets a Lady.** As a youth sail training ship and a floating environmental education classroom, the 136-foot-long *Adventuress* has become a familiar sight on Puget Sound. The schooner, built in 1913 in Maine, was purchased in 1974 by Ernestine "Erni" Bennett and operated by Youth Adventure Inc., a nonprofit organization, until 1991. It is shown here flying its topsails with the square-rigged brig *Lady Washington* off its bow in the background. (Courtesy Elizabeth Becker.)

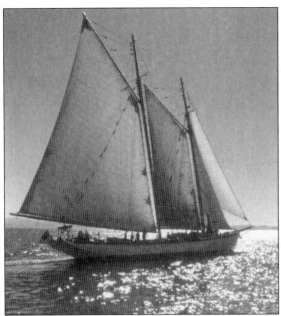

**SAILING FROM A TO Z.** The schooner *Zodiac*, built in 1924 in Maine, is another former San Francisco pilot schooner that offers sail training and adventure experience programs on Puget Sound. Purchased in 1975 and restored and operated as a family business for many years by early *Adventuress* captain Karl Mehrer and his wife, June, the 136-foot-long sailing vessel's primary master is now their son Tim. (Courtesy Vessel Zodiac Corporation.)

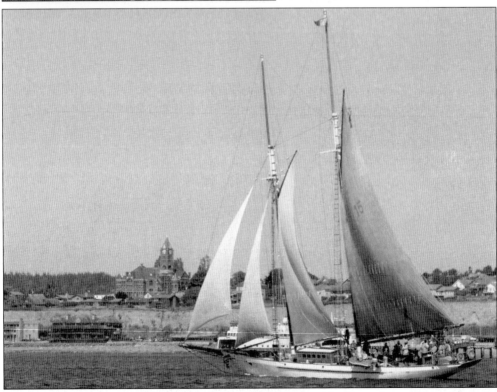

**ADVENTURESS WITH THE WIND.** The schooner *Adventuress* is shown here sailing along the waterfront of its home port, Port Townsend, with the Jefferson County Courthouse on the bluff in the background. Currently owned by Sound Experience, the nonprofit environmental organization offers educational programs for youth, adults, and families throughout the Puget Sound region. (Courtesy Elizabeth Becker.)

**"Youth of All Ages" Crew.** From its beginning in Puget Sound as a Boy and Girl Scout sail-training vessel, the *Adventuress*, under Erni Bennett's leadership, offered sailing, educational, and character-building opportunities for those she called "youth of all ages." Here under its current owner, Sound Experience, the multiage crew of the *Adventuress* hauls lines during a day-sail voyage. (Courtesy Elizabeth Becker.)

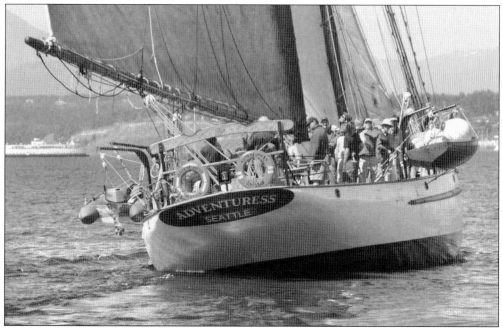

**Sailing Away.** The broad, 21-foot-wide beam and beautiful lines of the *Adventuress* are apparent in this stern view. The schooner was designed by Bowdoin B. Crowninshield, a widely regarded New England naval architect of the early part of the 20th century, for John Borden II, the founder of the Yellow Cab Company. (Courtesy Elizabeth Becker.)

99

**"Cap" Raynaud at the Helm.** Capt. Adrian "Cap" Raynaud, here at the wheel of the *Adventuress* in 1989 when he was 94 years old, was a legendary figure in Pacific Northwest and West Coast sailing history. Beginning as a sailmaker in San Francisco, he signed aboard major sailing ships at an early age and was one of the last of the square-rigger sailors to sail around Cape Horn. As a Seattle ship surveyor in later life, Cap became a confidant and good friend of Erni Bennett and supervised the carefully planned, ongoing restoration of the *Adventuress* for many years. (Both courtesy Karla Fowler.)

**ADVENTURESS AND EAGLE.** In 1978, the white-hulled *Adventuress* (center) joined the U.S. Coast Guard bark *Eagle* (background, right) in the inner harbor at Victoria, British Columbia. The occasion was the bicentennial of British Navy captain James Cook's voyages to the Pacific North coast in 1778 and the 1978 Tall Ships Pacific races, sponsored by the American Sail Training Association. (Courtesy Dorothy Rogers.)

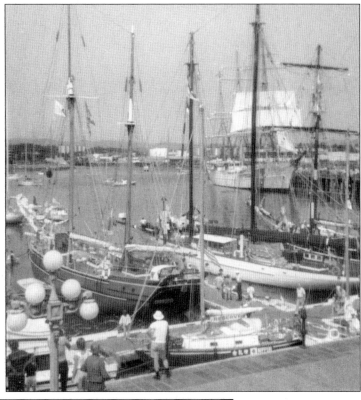

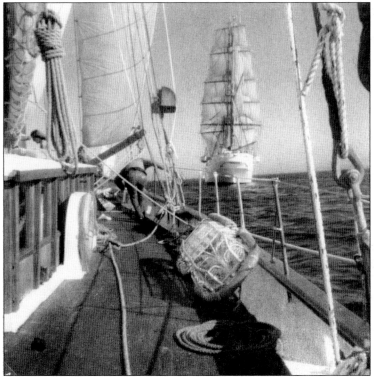

**ADVENTURESS IN THE PARADE OF SAIL.** With an all Girl Scout crew aboard, the *Adventuress* proudly followed the Coast Guard's *Eagle* during the 1978 Captain Cook Bicentennial parade of sail event in Victoria, British Columbia. Scout leader Dorothy Rogers recalled that the parade of ships and a later onboard tour of the *Eagle* by the Girl Scout crew and volunteer leaders were never-to-be-forgotten tall ship sailing experiences. (Courtesy Dorothy Rogers.)

**WASHINGTON SHIPS FLOTILLA BROCHURES.** In response to an invitation from EXPO 86, the Vancouver, British Columbia, Worlds Fair held in 1986, the State of Washington sent a fleet of 16 historic and classic vessels, including the *Adventuress*, to participate in the event. Sponsored by the 1989 State Centennial Commission, the flotilla visited seven Puget Sound port communities during its voyage from Olympia, Washington, to Vancouver. (Courtesy CM3 Associates.)

**FLOTILLA FAREWELL.** The departure of the Wilkes Heritage Flotilla schooner *Suva* from the Seattle's Shilshole Marina is covered by a television station news crew. The schooner was owned and operated by its master, Bill Brandt of Olympia, who also served as the commodore and operations planner for the more than 200-mile voyage from south Puget Sound to British Columbia. (Courtesy CM3 Associates.)

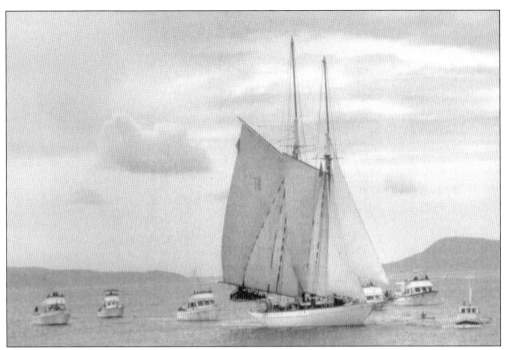

**ADVENTURESS ESCORT.** Surrounded by yachts, the schooner *Adventuress* received a welcome to port escort during its participation in both the Washington Ships Flotilla in 1986 and the Wilkes Heritage Flotilla in 1987. Ceremonies, shore-side dinners, entertainment, and other community activities were part of the flotilla projects. (Courtesy CM3 Associates.)

**WILKES HERITAGE FLOTILLA INFORMATION.** A brochure with a distinctive logotype provided information about the Wilkes Heritage Flotilla in July 1987. The event commemorated the first U.S. government–sponsored exploring expedition to the Pacific Northwest and Puget Sound in 1841 and was held in conjunction with a major Smithsonian Institution traveling exhibit at the Washington State History Museum in Tacoma. (Courtesy CM3 Associates.)

**DEPARTING GIG HARBOR.** The Wilkes Heritage Flotilla, sponsored by the Washington Centennial Commission, sailed on its second leg from Gig Harbor to Tacoma. Here the schooner *Suva* follows four other ships of the commemorative fleet toward Point Defiance. During his 1841 expedition, Charles Wilkes named both Point Defiance and Gig Harbor. (Courtesy CM3 Associates.)

**ERNI AND WILKES REENACTORS.** As part of the Wilkes public education and outreach program, three reenactors portrayed key participants in the mid-19th-century expedition. Shown here with Youth Adventure president and *Adventuress* steward Erni Bennett are (from left to right) Doug McDonnell as U.S. Navy Lt. George Sinclair, James DePew as boatswain's mate Charles Erskine, and Bob Copeland as lieutenant and later commodore Charles Wilkes. (Courtesy Youth Adventure, Inc., Sandra Bennett.)

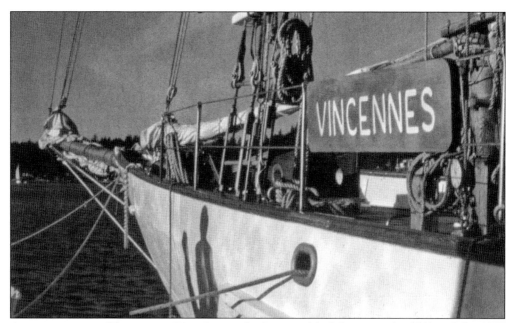

**ADVENTURESS AS VINCENNES.** To enhance the historical link between the 1841 and the 1987 eras, each of the seven Wilkes Flotilla sailing vessels was outfitted with flags, masthead pennants, and name boards featuring the name of the original ship they were portraying. The *Adventuress* is shown with the name board for the *Vincennes*, Wilkes's flagship during his 1841 exploration of Puget Sound. (Courtesy CM3 Associates.)

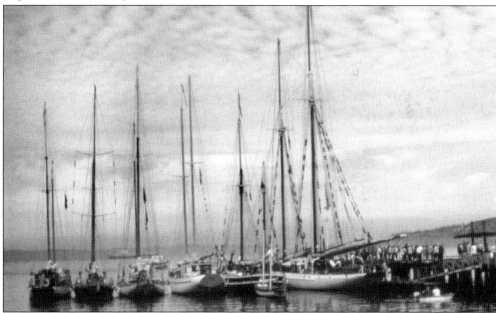

**FLOTILLA AT OLD TOWN, TACOMA.** The Wilkes Flotilla was welcomed by crowds at the Old Tacoma dock during one of its seven port calls. The fleet is shown rafted together during welcoming ceremonies that featured a cannon salute, a historic military regiment escort, and presentations. From left to right, the vessels are *Suva, Rose of Sharon, Martha, Passing Cloud, Sylvia,* and *Adventuress.* (Courtesy CM3 Associates.)

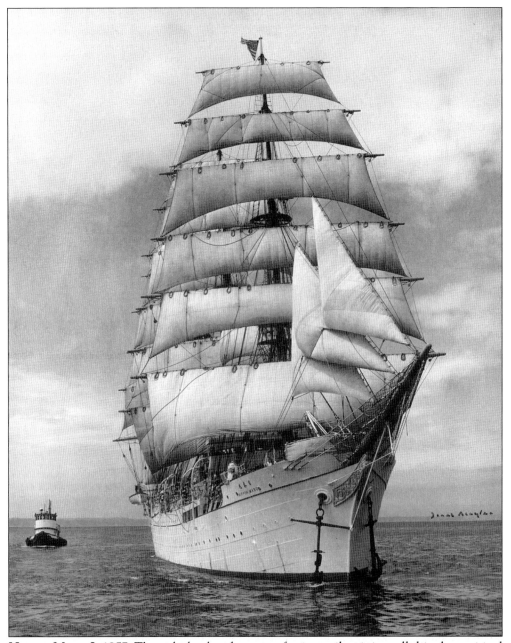

**NIPPON MARU I, 1957.** Through the decades, many foreign, sail-training tall ships have visited Puget Sound ports. In 1957, Japan's *Nippon Maru I* called at Seattle during one of its many training and international goodwill voyages to the region. The four-mast bark was built in 1930 for the Japanese merchant marine institute to train future ship officers. (Photograph courtesy MOHAI, Scaylea No. 1993.20.290.)

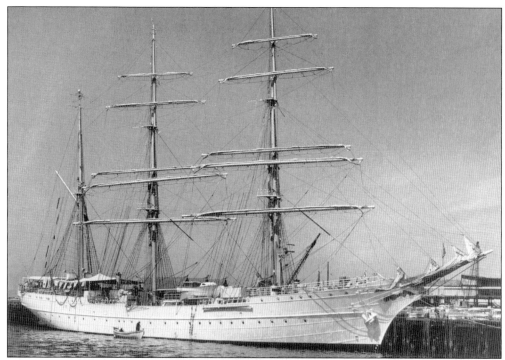

**U.S. COAST GUARD BARK EAGLE, SEATTLE.** Based at the Coast Guard Academy in Groton, Connecticut, the three-mast bark *Eagle* has visited Puget Sound twice on its summer cadet training voyages, in 1965 and 1978. Shown here in 1965 at the Washington State Ferries terminal dock in Seattle, the *Eagle* was formerly the German sailing ship *Horst Wessel* and was received by the United States as part of war reparations after World War II. (Courtesy PSMHS, No. 5539-4.)

**NIPPON MARU II EN ROUTE TO OLYMPIA.** The *Nippon Maru II* was invited by Washington governor Booth Gardner to visit Seattle and also the state capital in Olympia during the State Centennial commemoration in 1989. The 361-foot long, four-mast tall ship was the first major national sailing ship to visit Olympia since the visit of the USS Constitution in 1933. (Courtesy CM3 Associates.)

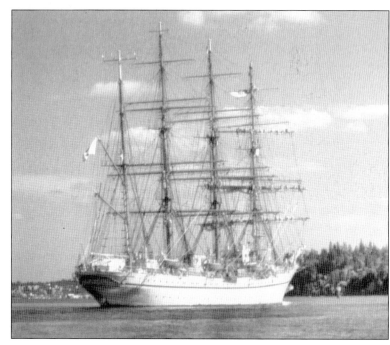

**CHILEAN TALL SHIP *ESMERALDA*, SEATTLE.** Another international sailing ship to visit Puget Sound during the state's centennial year in 1989 was the Chilean barkentine *Esmeralda*, shown here at the historic Ainsworth and Dunn wharf, Pier 70, in Seattle. Launched in 1952, the 370-foot-long, four-mast ship is owned and operated by the Chilean Navy to train future officers in traditional navigation, ship-handling, and leadership skills. (Courtesy CM3 Associates.)

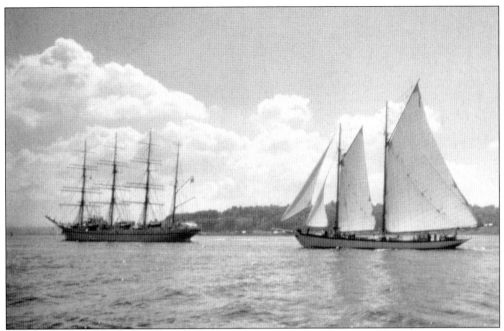

ZODIAC GREETS NIPPON MARU II. The schooner *Zodiac* was among the many Puget Sound–based sailing ships that welcomed the *Nippon Maru II* to Seattle in 1989. Shown here in Elliott Bay, the *Zodiac* joined others for a salute to the visiting Japanese tall ship that greeted visitors at Pier 70 on the downtown waterfront. (Courtesy CM3 Associates.)

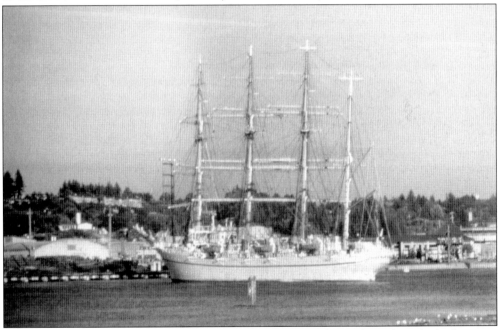

NIPPON MARU II IN OLYMPIA HARBOR. Because the Port of Olympia has a deep-dredged turning basin for oceangoing cargo ships, the *Nippon Maru II* was able to anchor in the inner harbor downtown area during its 1989 centennial year visit. The ship was an imposing sight during the day, and at night, its masts were rigged with strings of lights. (Courtesy CM3 Associates.)

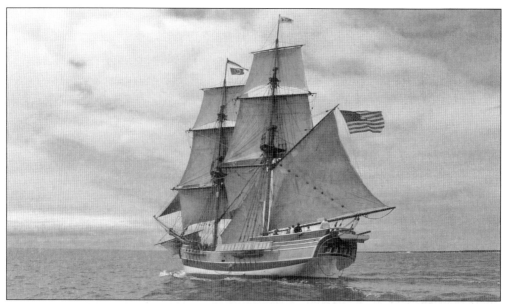

**LADY WASHINGTON UNDER SAIL.** The square-rigged brig *Lady Washington* was built in Aberdeen and launched in 1989 as a state centennial commemoration project. Named Washington's official state ship in 2007, the sailing vessel is an authentic representation of one of the first two American ships sailed by merchant trader captains Robert Gray and John Kendrick to the Pacific North coast beginning in 1787. (Courtesy Chuck Fowler.)

**SPACE NEEDLE AND THE LADY.** With the Space Needle shown through its standing rigging, the historical brig *Lady Washington* has been a frequent visitor to Seattle, both on the waterfront and in Lake Union. From its home port in Grays Harbor on the Washington coast, the *Lady Washington* visits Puget Sound annually during the summer. (Courtesy Chuck Fowler.)

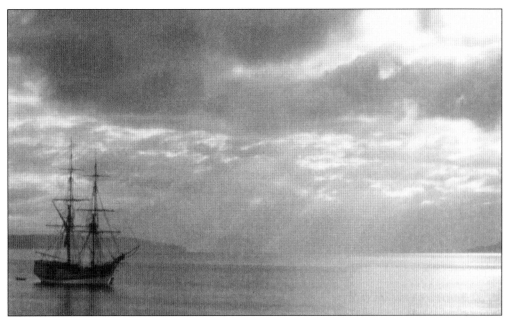

SUN RAYS ON TALL SHIP. At anchor in Penn Cove near Coupeville, the *Lady Washington* is bathed in sun rays streaking through morning clouds during a special tall ships visit in 2002. The ship makes living history–focused port calls in many communities in Puget Sound each summer during its active sailing season. (Courtesy Chuck Fowler.)

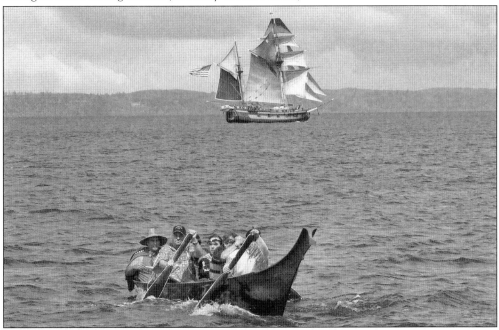

CROSS-CULTURAL CONNECTIONS. With the square-rigged sailing ship *Hawaiian Chieftain* in the background, a Salish canoe with Shoalwater and Chinook tribal paddlers returns from ceremonies welcoming and granting permission for the ship and its crew to come ashore. Such traditional, mutually respectful ceremonies have occurred increasingly in Puget Sound, Grays Harbor, and elsewhere in Washington State during the past two decades. (Courtesy Chuck Fowler.)

**SYMBOLIC WATERS TRANSFER.** As part of a statewide Washington Coastweeks program in 1991, the Wilkes Expedition of 150 years earlier was used as the historical basis for an environmental "caring for our waters" project. Here a Nisqually tribe representative transfers a container of water from the Nisqually Glacier and River to Clint Cannon, portraying U.S. Navy lieutenant Charles Wilkes, to symbolize a new people-to-people partnership to preserve water quality. (Courtesy CM3 Associates.)

**ENVIRONMENTAL PROGRAM TALL SHIP.** Retired army officer Clint Cannon, as Lt. Charles Wilkes, stands on the deck of the schooner *Rose of Sharon*. Owned by Byron and Sheree Chamberlain, the 1930 wooden schooner and Wilkes reenactors traveled through Puget Sound as part of the 1991 Coastweeks Exploring Expedition project to gather symbolic sample waters from several port communities and watersheds. (Courtesy CM3 Associates.)

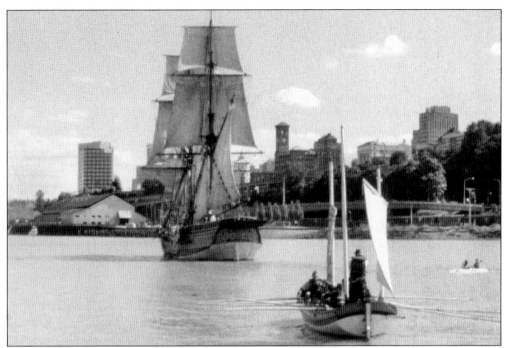

**LADY AND LONGBOAT IN TACOMA.** To preview the major Tall Ships Challenge event scheduled in Seattle and Puget Sound in 2002, the brig *Lady Washington* and four other traditional-design sailing ships gathered in Tacoma in 2001. Here the *Lady Washington* and one of its longboats, crewed by Tacoma Sea Scouts, approach the historic downtown waterfront. (Courtesy CM3 Associates.)

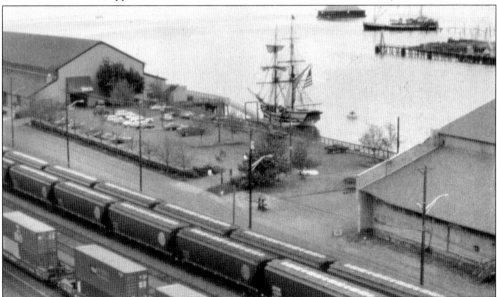

**MAKING NEW HISTORY.** Although historically the original *Lady Washington* never entered and explored Puget Sound in 1792, the representation of the ship has visited 18 times since it was launched in 1989. The *Lady Washington* is shown here in 2000 moored at one of Tacoma's century-old, restored, and rehabilitated wheat warehouses on the Thea Foss Waterway. (Courtesy Chuck Fowler.)

TACOMA TALL SHIPS PREVIEW, 2001. The classic views of the Tacoma waterfront with tall ships at the docks in the late 1800s and early 1900s were re-created in 2001 when five tall sailing ships visited Tacoma. The fleet consisted of (from left to right) *Lady Washington*, *Robert C. Seamans*, *Red Jacket*, *Quisett*, and *Suva*. It was a preview of the city's major tall ship event planned for 2005. (Courtesy Chuck Fowler.)

SQUARE-RIGGERS RETURN. History repeats itself after more than a century in this scene in Tacoma showing the newly launched, 134-foot-long brigantine *Robert C. Seamans* (right) and the *Lady Washington* at the historic grain warehouses dock. Launched in 2001, the *Seamans* was built by Tacoma's J. M. Martinac Shipbuilding Company for the Sea Education Association of Woods Hole, Massachusetts. (Courtesy Chuck Fowler.)

**TALL SHIPS CHALLENGE UNDERWAY.** The American Sail Training Association (ASTA), a nonprofit youth sail education organization based in Newport, Rhode Island, coordinates a series of races and port visits called the Tall Ships Challenge program. An advertisement promotes the 2002, 2003, and 2004 regional events, which are held annually on a rotating basis on the Atlantic coast, Pacific coast, and in the Great Lakes. (Courtesy American Sail Training Association.)

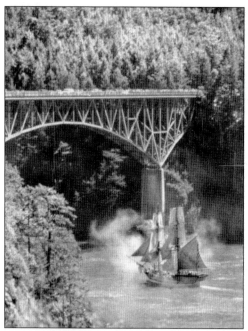

**LADY WASHINGTON BRIDGE PASSAGE.** With smoke from a cannon salute swirling around the ship, the *Lady Washington* passes under the Deception Pass bridge en route from Anacortes to Seattle during the 2002 Tall Ships Challenge event in Puget Sound. More than 20 tall sailing ships participated in the event, which also included a port call at Steveston Village in Richmond, British Columbia. (Courtesy Chuck Fowler.)

**TALL SHIPS VIEWPOINT.** Spectators at Seafarers' Memorial Park in Anacortes view the *Lady Washington* (left) and the *Hawaiian Chieftain* moored at Cap Sante Boat Haven. Hundreds of visitors toured these and other ships of the Tall Ships Challenge fleet during its 2002 stopover in the community, which promotes itself as a San Juan Islands gateway destination. (Courtesy CM3 Associates.)

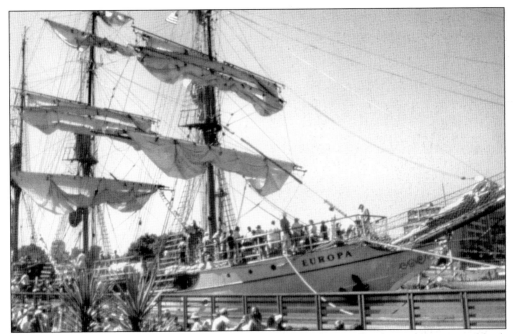

**EUROPA IN THE CITY.** Crowds in Seattle line up to tour the 181-foot-long, square-rigged bark *Europa* from the Netherlands during her 2002 Tall Ships Challenge (TSC) port call. The visiting tall ships fleet helped showcase the city's maritime history, historic exhibit ships, and developing Lake Union Park, where all the vessels were moored. (Courtesy CM3 Associates.)

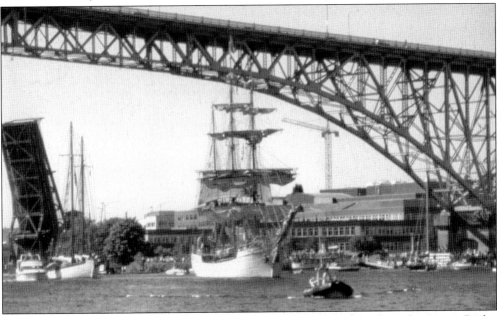

**BRIDGE TO THE PAST.** The *Europa* passes under what is known commonly as the Aurora Bridge in Seattle as it enters Lake Union during the 2002 TSC event. A major, more-than-160-foot-long sailing ship had not been in the lake since the last of the old square-riggers laid up there during the 1920s; the *Monongehela* and *Moshulu* were towed out in 1931 before the bridge's deck spans were joined. (Courtesy Chuck Fowler.)

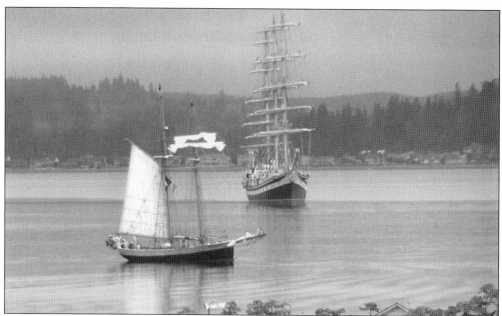

INTERNATIONAL SHIPS HARBOR. During the second Tall Ships Challenge in Puget Sound in 2005, the topsail schooner *R. Tucker Thompson* from New Zealand (left) and the Russian three-mast, full-rigged ship *Pallada* made a stopover visit to Port Madison. Similar American and foreign sailing ships loaded lumber at the small community's mill from the 1850s to 1880s. (Courtesy 2005 Port Madison Tall Ships Committee.)

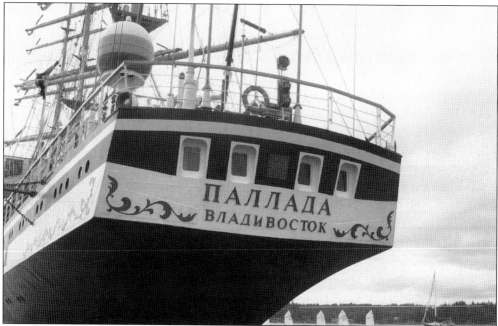

HANDSOME TRANSOM. The name of the ship, *Pallada*, its home port, Vladivostok, and traditional decorative designs are shown in this view of its impressive transom. The traditional-design sailing ship was built in 1989, one of nine constructed at the Gadansk shipyard in Poland for the former Soviet Union. (Courtesy 2005 Port Madison Tall Ships Committee.)

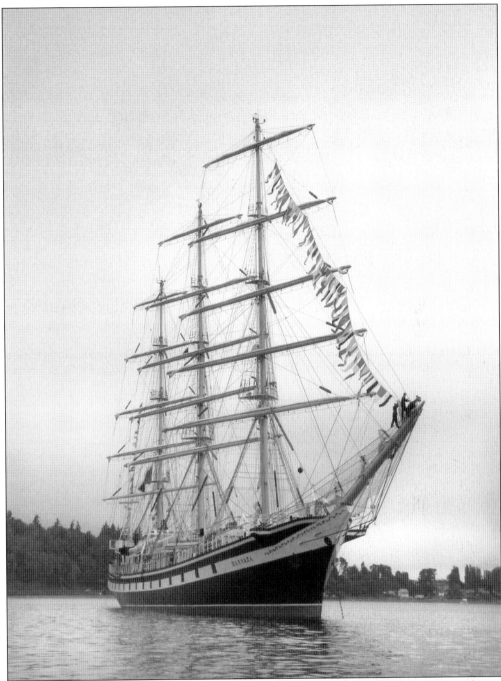

**FLAG-FESTOONED TALL SHIP.** Dressed with flags at anchor, the 356-foot-long *Pallada* is an impressive sight. Classified as a full-rigged ship, the designation means that it has square sails on all three of its masts. When all sails are unfurled, it flies more than 32,000 square feet of canvas. (Courtesy Tacoma Regional Convention and Visitor Bureau.)

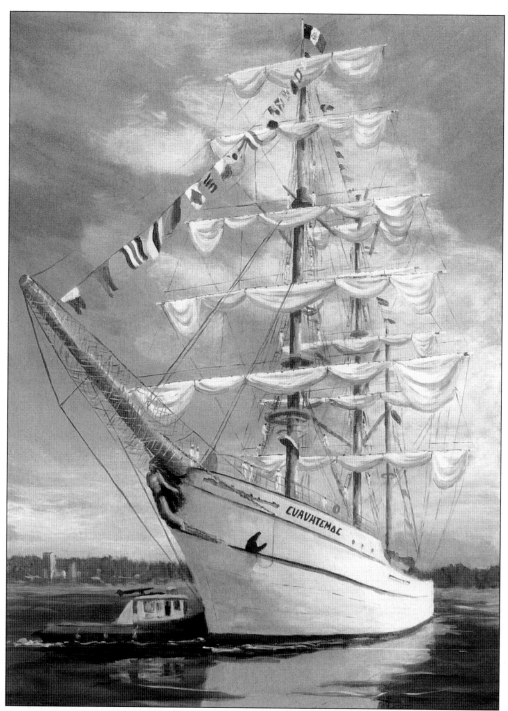

SAILING SHIP ASSIST. A tugboat assists the three-mast Mexican bark *Cuauhtemoc* to its moorage in this contemporary painting by Karla Fowler. From its home port in Acapulco, the 270-foot-long tall ship joined the *Pallada* in Tacoma as one of two major international ships that participated in TSC 2005. Tacoma, along with Victoria and Port Alberni, British Columbia, were the three official host ports in the Pacific Northwest for the event. (Courtesy Karla Fowler.)

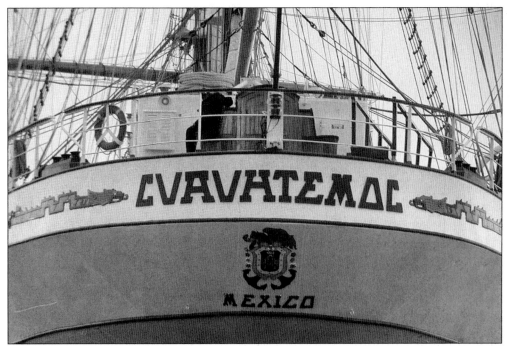

**SPECTACULAR STERN.** Similar to other national sailing ships, the stern of Mexican tall ship *Cuauhtemoc* features its ornately decorated name, hailing port, and, in this case, a heraldic crest. Operated by the Mexican Navy to train officers, the immaculate condition of the ship and the professionalism of its crew reflect strong national pride. (Courtesy 2005 Port Madison Tall Ships Committee.)

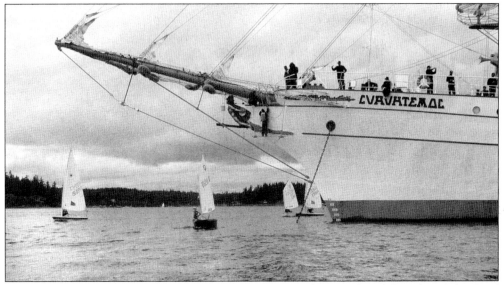

**TALL SHIP, SMALL SHIPS.** The small craft of the Port Madison Yacht Club Sailing School sail under the bowsprit of the Mexican tall ship *Cuauhtemoc* during a 2002 stopover in Port Madison on Bainbridge Island. The captains and crews of the Mexican and Russian ships participating in TSC 2005 joined local residents for an old-fashioned American beach party, a successful community welcoming event. (Courtesy 2005 Port Madison Tall Ships Committee.)

**WATERFRONT WELCOME.** The Mexican bark *Cuauhtemoc* dwarfs escorting yachts as the tall ship passes by crowds watching the Tall Ships Tacoma 2005 Parade of Sail from the Old Tacoma dock on the Ruston Way waterfront. An estimated 800,000 people viewed and toured the more

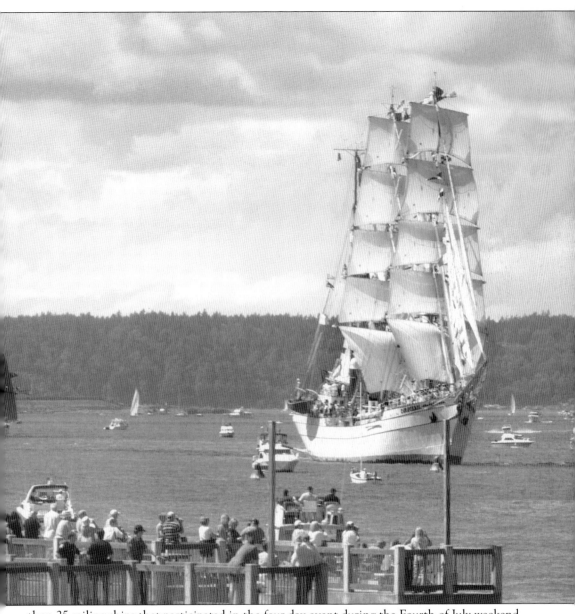

than 25 sailing ships that participated in the four-day event during the Fourth of July weekend. (Courtesy Ron Karabaich, Old Town Photo.)

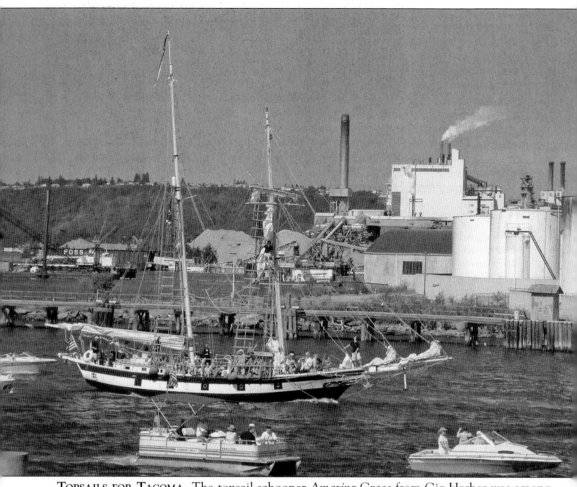

**TOPSAILS FOR TACOMA.** The topsail schooner *Amazing Grace* from Gig Harbor was among several square-rigged traditional sailing ships involved in the TSC 2005 event in Tacoma. Others included the *Hawaiian Chieftain* and *Lynx* from California, and the *R. Tucker Thompson* from New Zealand. A topsail schooner is a two or more mast vessel with a square-rigged sail on the foremast. (Courtesy Tacoma Regional Convention and Visitors Bureau.)

**VISITING CANADIAN SCHOONER.** The builders and owners of the 13-foot-long schooner *Pacific Grace*, the Sail and Life Training Society of Victoria, British Columbia, revised its busy 2005 summer sailing schedule to participate in Tacoma's tall ships event. The schooner and its sister ship, the 111-foot-long topsail schooner *Pacific Swift*, offer youth sail training and life education voyages in British Columbia waters and offshore in the Pacific Ocean. (Courtesy Tacoma Regional Convention and Visitors Bureau.)

**SAILING SHIP HOMETOWN HEROES.** The crew of the 90-foot-long yawl *Odyssey* hosts touring visitors onboard during the 2005 Tacoma Tall Ships event. Owned and operated by the Tacoma Sea Scouts, the tall sailing ship is berthed at its new base, the Commencement Bay Marine Services marina on Thea Foss Waterway. (Courtesy Tacoma Regional Convention and Visitors Bureau.)

**TALL SHIPS RETURN TO TACOMA.** After more than a century, history repeated itself when two major square-rigged ships, the *Cuauhtemoc* and *Pallada*, were tied up at the former McCormick Terminal dock on June 30, 2005, to open the Tacoma Tall Ships event. However, instead loading ships with grain and other projects destined for foreign ports, these visiting foreign ships brought the future leaders of their countries, as well as the goodwill of their nations and their people. It was a memorable four days for the crews of the participating tall ships and also for the hundreds

of thousands of spectators and visitors who experienced the majesty of these traditional sailing ships and the pride of their crew members. The spectacular event earned Tacoma the prestigious American Sail Training Association 2005 Port of the Year award. Building on the experience of Tall Ships Seattle 2002 and Tacoma Tall Ships 2005, the stage has been set for writing a fascinating new tall ships future for the entire Puget Sound region. (Courtesy Ron Karabaich, Old Town Photo.)

# ACROSS AMERICA, PEOPLE ARE DISCOVERING SOMETHING WONDERFUL. THEIR HERITAGE.

Arcadia Publishing is the leading local history publisher in the United States. With more than 4,000 titles in print and hundreds of new titles released every year, Arcadia has extensive specialized experience chronicling the history of communities and celebrating America's hidden stories, bringing to life the people, places, and events from the past. To discover the history of other communities across the nation, please visit:

## www.arcadiapublishing.com

Customized search tools allow you to find regional history books about the town where you grew up, the cities where your friends and family live, the town where your parents met, or even that retirement spot you've been dreaming about.